DEVELOPING THE
D.I.V.A.
DIVINELY INSPIRED VIRTUOUS ASSET™

in you

DR. TERRI SMITH-LITTLE

DESTINY IMAGE EUROPE™ srl
Via Maiella, 1
66020 San Giovanni Teatino (Ch) - Italy

"Changing the world, one book at a time."

This book and all other Destiny Image Europe™ books are available at Christian bookstores and distributors worldwide.

To order products, or for any other correspondence, please contact:

DESTINY IMAGE EUROPE™ srl
Via Acquacorrente, 6
65123 - Pescara - Italy
Tel. +39 085 4716623 - Fax: +39 085 9431270
E-mail: info@eurodestinyimage.com

Or reach us on the Internet: **www.eurodestinyimage.com**

ISBN: 978-88-89127-54-4
For Worldwide Distribution, Printed in the U.S.A.
1 2 3 4 5 6 7 8 / 11 10 09 08

Dedication

This dedication is twofold:

This message was first delivered two days after I buried my only sister, Michelle R. Smith-Newton. Seeing my sister die an early death without fulfilling her destiny ignited a passion within me to bring women from obscurity to prominence.

<div align="center">

Shelley, this book is for you!
Michelle R. Smith-Newton
March 20, 1952–September 17, 1998

</div>

Also to my four D.I.V.A.s: Joieux (Joi), T'nil, Shelbi, and Kristen. One of the greatest blessings of my life has been being your mother. I thank God for entrusting me with your lives. Although my responsibility is to impart the wisdom of God and lessons learned from my own life into you, each one of you has edified my life in a special way. Joieux, your compassion and love have been such an inspiration to me. You have the great quality of always seeing the good in everyone around you, and you bring the

best out of everyone you come in contact with. God made you my firstborn, and I am truly blessed. T'nil, your integrity has strengthened me, your encouragement has motivated me, and your steadfastness has allowed me to never give up! Shelbi, your vibrant personality, joy, and keen discernment have showed me how to celebrate our victories, to keep my head up when circumstances could have brought me down, and to truly know that with God *all* things are possible. And to my baby Kristen, your compassion, love, and genuineness has brought me comfort and peace and has given me the ability to share that love with others. I thank each of you for your unfailing loyalty as we've been through the valley and on the mountaintop. I've enjoyed sharing this journey of life with you and seeing you develop into the beautiful women you have become. May every word in this book give you the spiritual resources to reach your greatest potential!

And to my only son, Ottawa Pullen, III (Trey), the love and adoration that I feel for you goes deeper than anything I could have ever imagined as a young girl dreaming of having children. It's one thing for a mother to see her son grow up into a man, but it's another thing to see the goodness of God being developed in him, and that's what I see in you. Son, I'm godly proud of you. Trey, there are so many reasons why I wrote this book, and one of those reasons is you and the men of your generation. I've determined in my heart not to be part of another generation refusing to take responsibility for mentoring those coming after me. It's because of you and young men like you that the truth of God must be revealed to the women of the world, and as they get it right they can reach out to the men of God, their Boazes, with the confidence and tools to have successful relationships.

Acknowledgments

First and foremost I thank you, Lord, for redeeming my life from destruction and giving me unspeakable joy in this lifetime.

To my mother, Dr. Irene Hill-Smith, and to my father, Mr. Howard Smith: Thank you for instilling in a little black girl vision and tenacity to know that nothing was impossible if she just believed.

To Rev. W. D. Willis: You created an atmosphere of love and acceptance in the church world that has remained with me over the last forty years. Thank you, and may the Lord continue to bless and keep you.

To my spiritual father, the late Pastor John Osteen, who recognized and developed the gift in me when I didn't even see it in myself. His words of encouragement, correction, and love are ever present with me: I thank the Lord for the day I walked into Lakewood Church and for the personal mentoring Dr. Osteen gave me.

To my mentor, spiritual mother, and friend, Pastor Maryellen Lewis: Thank you for your unconditional love, honesty, and persistence in helping mold me into God's chosen vessel.

To the staff of Love Ministries International (LMI) and D.I.V.A. International: You are the greatest supporters. I thank you for helping this vision to manifest.

To Denise McDade: Thank you for helping bring this assignment to life. You have made my dream a reality.

To my ministry friends and partners: Your prayers and support have been a source of strength that has empowered me to continually enrich the Kingdom. Thank you!

Contents

IMPARTATION III: *Virtuous*

IMPARTATION IV: *Asset*

A D.I.V.A. Is...?

I will praise Thee; for I am fearfully and wonderfully made: marvellous are Thy works; and that my soul knoweth right well (Psalm 139:14).

WHEN GOD FIRST GAVE ME the word D.I.V.A. and said it would be the name of our international women's organization, I had to stop and think about that. He said that women all over the world used the word but no one had a real definition of what a D.I.V.A. was—until now.

D.I.V.A. stands for Divinely Inspired Virtuous Asset. A D.I.V.A. is a dynamic creation cut from the very existence of God the Father, the Master Creator. She was first introduced to mankind as a helpmeet for the first man, Adam. However, as times, customs, people, and expectations for women have changed, so has the role that women play in our society. But the original design and purpose of women has never changed in the heart and mind of God.

God told me that every one of us is an "original" made from Him. We come here originals, and yet we are always trying to mimic someone else. We're trying to look like, dress like, and act like someone else, never trying to develop the gift that is within us. The sad thing is, we are the originals, and if we don't change our way of thinking and doing things, we will die poor copies of something we were never meant to be.

Within the pages of this book, I'm going to show you step-by-step God's purpose for women, rooted deep within the Word, thus helping you get rid of everything that has ever kept you from your purpose in God. The lessons you will learn may not be easy, but they will be well worth the effort you are willing to invest in yourself. With every page you will discover God's original intent for you. You will be empowered to make the decisions necessary to gain the control over your life that has eluded you in the past. Then you will see yourself like never before; you will see that what appeared to be a lump of coal was really a clear-cut diamond. It's not going to be a princess cut or pear shape or heart shape or any other man-made cut. This is going to be an original D.I.V.A. cut, directly from the heart of God, shining bright for all the world to see.

There is one important thing that you should know about a D.I.V.A.-cut stone: because it has been created and perfected by the very Master Creator Himself, no two stones are alike. Therefore, we must learn to embrace all of our differences. We each need the gifts, talents, strengths, and insights that we get from one another.

So, we are doing away with the world's idea of what a diva should be. The only thing that genuinely matters is what God has to say. In this dispensation, He is calling every woman of God a D.I.V.A.—a Divinely Inspired Virtuous Asset. No matter how hard that is for you to believe now, before you are finished with this book, you will believe.

This is not something we are going to take to the extreme, either. This isn't a platform for male bashing. As Christians, we have

a tendency to jump in the ditch on one side or the other. God insists that we have a balanced life. This is simply a message to bring balance to the lives of women around the world. In establishing balance in ourselves as individuals, we will establish it in every other area of our lives.

So the lifelong battle that's gone on inside of you is coming to an end. You have battled for your identity, purpose, creativity, and structure. You have been battling for deliverance, destiny, power, and purpose. God is going to restore all of that through this one experience. We know this because He is saying, "The battle is not yours but Mine." One message could not give women all of this without God sending it in the fullness of time. The battle belongs to God, and He holds the victory.

Now, I want you to kick back and tell your husband and the kids you need a little downtime. Take a few minutes to unwind and calm down from your hectic day. Maybe fill the tub with some warm water and your favorite bath salts and light some candles. Then allow the anointing of the Holy Spirit to minister to you as you learn how to develop the D.I.V.A. in you.

Impartation I

Divinely

Divinely

ALL OF MANKIND HAS BEEN CREATED in the image and after the likeness of God. This means that every woman in existence was created to be a D.I.V.A. (Divinely Inspired Virtuous Asset). At first blush being referred to or seeing yourself as a D.I.V.A. may be a little overwhelming; nevertheless it is who you are, and it is time for you to accept this as a fact of life.

By accepting this revelation, you can now gain the understanding that when God created you He created you complete—having all necessary parts and elements that define who you are in Him. D.I.V.A., you are whole in every way—spirit, soul, and body; you are a complete package of divine origins.

Being complete in every way simply means that everything it takes to make you whole is already contained inside of you. There are no more steps to take; there are no other parts or elements to obtain to make you complete. Everything that you need can be found within you.

You may not see that you already have everything you need to be successful in life, basically because at some point the issues of life, which are rarely favorable, blinded you, and you have not grown beyond that point, spiritually or emotionally. This is why God is in the restoration business. God's promise to you is to restore you and put you on the path that He originally planned for your life. Because He created you, He and only He knows what it is going to take to get you to your destiny, and He is not willing to stop until you achieve victory.

In order for this to work in your life, you will have to trust God with all of the hidden places that you have not been willing to allow anyone to see. God has proven time and time again that He can be trusted. He knows every secret part inside of you, all of the intimate, shameful details. God is not condemning you, nor does He want to expose you, and yet neither will He allow you to live in the hurt and degradation of your past any longer. He offers a level of freedom for your life that surpasses anything you could ever obtain for yourself.

Therefore, as you learn how to allow God to restore you to who He created you to be, you will see restoration spilling over into every other area of your life. Before you realize what has happened, you will know that you are a Divinely Inspired Virtuous Asset. Look in the mirror and say out loud, "I am a D.I.V.A."

Chapter I

Lord, Restore Me

THIS IS A MESSAGE OF COMPLETE restoration to the women in the Body of Christ. Restoration, the true essence of the word, means to take an action that will bring something back to the original intent of the creator. However, the thing being restored is now stronger, better than it was in the beginning.

When you purchase antiques that have been restored, you are going to pay more for them than when they were brand new. Now that they have weathered some storms, they have taken on more character. They now are reinforced in places that were broken under pressure and because of misuse. But now, the life of the thing takes on new meaning, and it should never break in those same places again.

This is why it is worth more now than in the beginning. It has been in the hands of someone who knows how to handle it. It has been in the hands of someone who understands the intent that was in the heart of the creator. The restorer knows every part of the thing, even the secret

parts, and how those secret parts should be used. It has been in the hands of someone who can tell you exactly how to use it and how not to abuse it.

As women of God, we are now in the hands of someone who is not going to abuse or misuse us. Our Heavenly Father desperately wants us to know exactly what we were created for. God has some secrets to reveal to you that will revolutionize your life.

Through these pages, we are going to deal with some of those secrets graphically, yet biblically. They will be dealt with in decency and order, according to the Word of God. I am telling you up front I am going to say some things that just might shock and offend you, but hang in there. When it is all over, no one will be offended but the devil.

And God Blessed Them!

So God created man in his own image, in the image of God created he him; male and female created he them. And God blessed them, and God said unto them, "Be fruitful, and multiply, and replenish the earth, and subdue it: and have dominion over the fish of the sea, and over the fowl of the air, and over every living thing that moveth upon the earth" (Genesis 1:27-28).

God made male and female in His image and He "blessed them." They had authority, power, and dominion. The world has turned this entire work of God inside out, perverting the truth. They would have you believe that as the woman, you are not complete until you find a man. This means that all you should do is wait around for Mr. Right to come along to get your blessings: buy a new car or some diamonds, go on a cruise, or purchase a home. If all you are doing is waiting on Mr. Right so you can get married and get material possessions, you will be nothing more than a married prostitute.

You must understand that when God blessed the man, the blessing also went to the woman. The Scripture says, "And God blessed *them*." D.I.V.A., you are a very important part of "them."

If you see your Mr. Right as nothing more than a tool to get stuff, then you are just selling what you have to get what he has. We hear about prostitutes that walk the streets or that work as call girls, but there are many married ones that nobody wants to talk about. If we did start talking about them, they could get set free, and the next generation would not end up believing that this is the only way to live. These women are not married because they want to be a wife or submit to a man or even because they want to build a family for the Kingdom of God. They are married because they want to get possessions, recognition, and influence. They think this will be the easiest way to do it. There is no easy way—but the Bible teaches there *is* a godly way. This is what we are developing in you, biblical truths that will take you to the next level in God.

The Word says that God "blessed them." As a woman, you need to understand that you are already blessed. You are a part of "them." All you have to do is stand up and take dominion over what God has already given you. This means you are not waiting around for Mr. Right. You are doing your own thing until he finds you.

Whoso findeth a wife findeth a good thing, and obtaineth favour of the Lord (Proverbs 18:22).

The world would have you believe there is something wrong with you, that you are incomplete in some way, simply because you are not married or don't have a man in your life. However, the truth is the man had something taken out of him, so he is the one that is incomplete.

And the rib, which the Lord God had taken from man, made he a woman, and brought her unto the man (Genesis 2:22).

These two Scriptures do not say that the woman had to find anything or that she had anything taken out of her, making her incomplete. The man is incomplete, and it's his job to find the good thing that completes him. The world does not want to promote the truth of God's Word. The man is the one walking around with the limp because he is missing a rib; D.I.V.A., you are the complete one with the rib that fits. It is his job to find you.

And, please remember, don't allow your relatives, coworkers, friends, and neighbors make you think there is something wrong with you because you are not married. They will tell you, "You know, your clock is ticking" or, "The sun is about ready to set on you, baby." Then there are those who would have you believe that any old piece of man is better than no man at all. You try to tell them, "But he doesn't have a car, a house, or a savings or checking account, and he still lives with his parents." They come back with, "But you can teach him how to be a man." You must know what the Word of God says, instead of buying into that simple way of thinking. That stops today.

As a D.I.V.A., you are not sitting around waiting for Mr. Right to come along to approve and validate you. You know God has already approved and validated you, so you go on living your own life with your own stuff; you already have jewels, a house, a car, fine clothes, several bank accounts, and a vision from God. So when Mr. Right does come, you are already living in your palatial home. Then you can say, "If you can't handle all of this, then there's no sense in you coming."

If he cannot match that, then why is he there? When Mr. Right shows up, he improves or reproduces what is already there. God watched Adam a long time in the garden before He brought Eve into the picture. God was convinced that Adam could handle everything that He had given him to do. Then God presented Eve to Adam, but not before Adam had proven himself.

God has created and validated you already. However, you have never been taught how to receive and walk in that validation. Instead, you buy into this hype that you are nothing until some "wolf in sheep's clothing" comes along and validates you. But he cannot validate you because he has never been taught how to handle the treasure of the Kingdom. You, D.I.V.A., are that treasure.

You will misuse a thing when you have not been taught how to properly care for and handle it. If your Mr. Right comes along and begins to tell you, "You're nothing," and you believe him, it's only because you do not know that when God created you, He did a perfect job. God is saying to you, "I'm restoring my queens because the King has need of them." I don't know of any queen who has taken her rightful place of dominion and authority who is lacking anything. So if you're ready to take your place as a twenty-first-century queen and you know you're lacking in some areas, let's get your stuff back.

Jubilee

Then shalt thou cause the trumpet of the jubilee to sound… (Leviticus 25:9).

In the year of this jubilee ye shall return every man unto his possession (Leviticus 25:13).

Biblical restoration came during "the year of jubilee." This took place every fifty years, marked by the blowing of a trumpet-like instrument called a *shofar*. Once the shofar was blown and the sound went throughout the land, it marked the beginning of jubilee.

During this time, every man had to give back land and property that did not originally belong to him or his family. If you sold your land, personal property, or even yourself into servitude for whatever reason, it would all be given back to you or your family during jubilee, and all slaves were set free.

God is saying, "This is not your jubilee but Mine. And in My jubilee I'll have mercy on, restore, and deliver whom I want." Now D.I.V.A., listen to this: He wants to restore you! Since it is jubilee, it is time for you to receive from God the original plans He had for your life. In order for there to be room enough to receive what God has for you, you must first get rid of all the old junk in your life. This junk is stuff that God never intended for you to carry in the first place. It's time to recognize what doesn't belong to you and give it back to its original owner, the devil.

The Secrets of Conception

Unto the woman He said, "I will greatly multiply thy sorrow and thy conception; in sorrow thou shalt bring forth children; and thy desire shall be to thy husband, and he shall rule over thee" (Genesis 3:16).

This was the curse pronounced on the woman because of her disobedience and betrayal in the garden.

The Amplified version states, *"To the woman He said, 'I will greatly multiply your grief and your suffering in pregnancy and the pangs of childbearing; with spasms of distress you will bring forth children. Yet your desire and craving will be for your husband, and he will rule over you.'"* This gives us very important insight as to what happened and what can be done about it.

What happened was this: Childbirth was originally intended to be effortless for the woman and the child. But then the curse was pronounced and everything changed.

Have you ever watched one of those nature shows about animals, where they show the female giving birth? Or maybe you have pets at home and when it's time for them to give birth, you gather the kids around because you want them to share in this wonderful occasion. The animal just lies there and allows nature to take its course. Everything is calm, natural, and beautiful.

Then your children ask, "Mom is that what it was like when I was born?" You warmly reflect back to that glorious day when your blessed bundle of joy arrived. Then you shudder at the thought of the pain, screams, and threats. You remember thinking, "That's it. He'll never touch me again. As a matter of fact, he's moving to the sofa for the rest of our lives!" But then, sooner or later, things go back to normal, and you decide to have more children.

We put ourselves through this because once we hold our little bundle of joy for the first time, we realize it's really all worth it. Let's face it: If there were another way, we would go that route. But there isn't. Or is there?

The words spoken in Genesis 3:16 was the punishment or curse for disobedience. However, all curses were broken at Calvary.

> *Christ hath redeemed us from the curse of the law, being made a curse for us: for it is written, "Cursed is every one that hangeth on a tree"* (Galatians 3:13).

So what we should get from this is that disobedience led to a curse. However, because Jesus redeemed us from the curse of the law, things should be different. But they're not. Remember it's only the truth that you know that will make you free.

Now, if we've been redeemed from the curse of the law, then why does childbirth continue to be a hard and painful experience for both mother and child? I'm glad you asked.

Let's say, for instance, that your mother was raped, or maybe she was having an illicit affair with a married man and your conception was a result. You could have been an unplanned pregnancy. Maybe your mother talked about or even tried to have you aborted. Maybe your mother was dealing with feelings of inferiority, worthlessness, rejection, self-hatred, loneliness, or shame. She could have been married to your father and didn't feel as though he loved her. All of these negative emotions were floating around in her body, and upon conception, they were shot right into you. While you

were floating around in the amniotic fluid that was supposed to protect you in the womb, you were floating in feelings of inferiority and worthlessness, self-hatred, loneliness, shame, and rejection. For nine entire months, this is what was being infused into your soul.

This is why, for most of us, we've got to fight to be born. There are very few mothers who have had a smooth delivery. There was a fight to bring you here because rejection was saying, "I'm not going to let her come out." Inferiority was saying, "I'm not going to let her be born."

You were conceived and nurtured in an environment that was not conducive to a healthy birth. Once you were delivered, you came here with "baggage" that was not yours. You came out familiar with feelings of rejection, inferiority, worthlessness, self-hatred, loneliness, guilt, and shame. And none of it belonged to you.

While you were in the womb, God knew that there would be stuff that would come to attach itself to you that was not yours. This is why before you were ever born, God sanctified you unto Himself.

> *Before I formed you in the womb I knew [and] approved of you [as My chosen instrument], and before you were born I separated and set you apart, consecrating you; [and] I appointed you as a prophet to the nations* (Jeremiah 1:5 AMP).

You no longer have to carry around your mother's "excess baggage" or what came through your family line. It is not yours to begin with, and it is time to let it go. You do not have to carry around the fact that daddy did not love mama, or mama did not love daddy. You do not have to carry around the guilt and shame of the fact that mama was raped and your conception was a result of that rape. You no longer have to accept this as a way of life, and you no longer have to believe this is the way you are and always will be. You no longer have to accept the junk the enemy put on you before you were even born. It is not yours, and you must give it back.

Your entire life you've been reacting to circumstances and situations because of all of the negative junk that was put in you before you were ever born. Before you had a chance to live and experience life for yourself, to know how you should act and react, negative emotions from someone else were already dictating how you should live.

God wants you to know that you do not have to carry this garbage, because He knew you before you even existed in the earthly realm. He approved of you and sanctified you to Himself. He planted some things in you before the devil ever knew you were coming into this world. God never plays catch-up to what the devil has planned for your life. Therefore, everything God placed in you was good because it came from Him. This is what He wants you to understand: it's time to give back the bad stuff and develop the good stuff.

It's really because of all of the good stuff that God placed inside of you that you continue to try and make things better for yourself. That's why when you feel cast down, you keep pushing forward. That's also why when you feel rejected, you still believe that God is going to use you no matter what is going on in your life.

Now that it is jubilee and the time to give the devil back his stuff, you must make that decision. It is up to you whether you are going to give the enemy back all of his garbage that you have been carrying around for years. If you are determined to give it up, this would be a good place for you to blow your shofar by shouting unto God with a voice of triumph. Go on, D.I.V.A., shout the victory!

A shout or battle cry is a cry so loud it puts the spiritual realm on notice that someone in the natural realm is about to affect Heaven. It is also a cry so loud that Heaven splits and whatever you are in need of falls through the split. When you shout unto God with the voice of triumph, He has got to respond by releasing what you need. The level of your praise determines the level that Heaven will respond.

And at midnight Paul and Silas prayed and sang praises unto God: and the prisoners heard them. And suddenly there was a great earthquake, so that the foundations of the prison were shaken: and immediately all the doors were opened, and every one's bands were loosed (Acts 16:25-26).

This is the perfect example of what happens when the people of God cry out to God with a voice of triumph. Paul and Silas prayed and sang praises unto God at midnight, and what happened? Heaven responded! If they had been sitting there quietly believing God, nothing would have happened. They never asked God for anything, they just praised Him. When you shout unto God with the voice of triumph, He must respond by releasing the very thing that you need, which is Heaven's best. There is an old hymn that says, "Don't wait until the battle is over, shout now!"

Now that you've gotten some understanding, given the devil back all of his junk, and "gotten your shout on," it's time to rebuild your foundation. So when you finally stand before the world, you won't be standing in your own strength. You'll be standing in the glory of God, and everyone will marvel at the D.I.V.A. that you've become.

CHAPTER 2

Covered by the Blood

And Adam said, this is now bone of my bones, and flesh of my flesh: she shall be called Woman, because she was taken out of Man (Genesis 2:23).

NOW THAT YOU'VE GIVEN THE enemy back his stuff, it's time for you to get an understanding of how God actually meant for man and woman to coexist. God, before the sixth day in the garden, had man living and existing inside of Himself. God knew man, or Adam, long before He actually made him and breathed the breath of life into him. This was something so wonderful, so marvelous, that He didn't share His plans with anyone.

Just as at your conception you were infused with everything that was inside your mother, Adam was infused with everything that was inside of God. Adam received absolutely everything that pertained to life and godliness because there is only good within God. Then, in the fullness of time, God brought Adam forth. After

being made in God's image, Adam was instructed to have dominion and authority over everything that God had created.

> *And God said, "Let Us make man in Our image, after Our likeness: and let them have dominion over the fish of the sea, and over the fowl of the air, and over the cattle, and over all the earth, and over every creeping thing that creepeth upon the earth." So God created man in His own image, in the image of God created He him; male and female created He them. And God blessed them, and God said unto them, "Be fruitful, and multiply, and replenish the earth, and subdue it: and have dominion over the fish of the sea, and over the fowl of the air, and over every living thing that moveth upon the earth"* (Genesis 1:26-28).

In these verses, God does three different things. However, I want you to notice exactly who it is God is referring to. First, He declares what He is going to do: "let us make man in Our image" and "let them have dominion." Next, He does what He has declared: "God created man" and "male and female created He them." Then He gives His creation instructions as to what purpose he (or they) will fulfill on the earth, "God blessed them, and God said unto them." During the entire time God was declaring, creating, and instructing, He was referring to "them" as male and female.

As Adam, or they, or male and female, went about doing what God had instructed them to do, God noticed something.

> *...but for Adam there was not found an help meet for him* (Genesis 2:20).

This is when God put Adam to sleep and made Eve.

> *And the Lord God caused a deep sleep to fall upon Adam, and he slept: and He took one of his ribs, and closed up the flesh instead thereof; and the rib, which the Lord God had taken from man, made He a woman, and brought her unto the man* (Genesis 2:21-22).

Adam was in God, and everything good in God was poured into Adam; then, when the fullness of time had come, God brought him forth. The exact same thing happened with Eve. All the goodness that had come from God and that existed in Adam was poured into Eve, and in the fullness of time God brought forth Eve.

Once Adam saw the woman, he said, "This is now bone of my bones, and flesh of my flesh: she shall be called Woman, because she was taken out of Man" (Gen. 2:23).

Have you ever wondered why God used Adam's rib? God didn't just choose a bone at random; this was very strategic. God, in all His wisdom, took a part of man that would implicate position and purpose. Remember, God wanted a "helpmeet" for Adam.

By taking a bone from the very part of the body that is meant to protect, He was demonstrating that the connection between man and woman would be twofold. First, the rib cage is designed to protect the vital organs that are essential to all existence. Secondly, the bone is designed for structure and strength. Adam, from his own mouth, spoke the very words that would establish their relationship. Their purpose would be to protect and strengthen one another.

D.I.V.A., you are not weak or worthless; you play a very vital role in the Kingdom. There is purpose and destiny inside you. There is protection and strength inside you. When Mr. Right comes along, you are already established in the things of God. Together, the two of you can stand strong and build something for the Kingdom of God and generations to come. You were never meant to assist him in being weak or leave him unprotected.

The other thing Adam said was that the woman God brought him was "flesh of my flesh." Skin is the largest organ on the body. It covers the entire body from head to toe. It's amazing God took a small, but in no way insignificant, bone to show how a woman is to help protect and strengthen man and help him stand. But then to demonstrate how He wanted woman to cover man, He used the

skin, the largest organ on the body. So how is a woman supposed to cover a man? She is to cover him with her mouth. It's the words that she allows to come out of her mouth or that she doesn't allow to come out of her mouth that cover him. Let's face it, ladies, this is the one thing that has always gotten us into trouble. We have a tendency to share the wrong thing at the wrong time.

If your husband does something that hurts or upsets you, the first thing you do is get on the phone to tell your best friend, your mother, or your sister. You'll go to everybody except God. The truth is, they're all listening to you from the point of their pain. The pain is out of their past, unresolved issues that they have neither turned over to God nor placed under the blood. So in essence, you're really not getting godly counsel, are you?

So you have just uncovered the very thing you were put here to cover. Let there be no mistake: it is an abomination for a woman to uncover or discuss her husband with other women in a negative manner, and a lot of the positive things that are said you should keep to yourself. It's bad when a woman discusses the private things that go on between her and her husband with her girlfriends and her mother, but it's even worse when these issues are discussed with your children.

No matter what goes on between you and your husband, it should never be discussed with your children. After it is all said and done, he is still their father, and they will still be held accountable to God for honoring both of you.

> *Honour thy father and thy mother: that thy days may be long upon the land which the Lord thy God giveth thee* (Exodus 20:12).

Listen, I'm not just spouting off something because it sounds good. I know this to be the truth, and I know it because of personal experience.

My Personal Testimony:
Covered by God, Uncovered by Man

You may think the easiest thing would be to receive a revelation like this and go around the world teaching women what God has in store for their lives, but for me it hasn't always been easy. I didn't just receive this revelation. It's come after many mistakes and much heartache. Yes, I've gone through some things, and yes, I've come out with more than just life lessons. There is an anointing on my life that's able to reach down and pull you up from where you are to where God wants you to be. This is God's anointing that rests on me. The Word says that the anointing destroys the yoke. Since I know it has destroyed yokes in my life, I can say unequivocally that it will destroy them in your life.

I came from a very prominent, upper-middle-class family. I had a very strong, outspoken mother. She was a woman who never heard the term "submissive wife." Early on, I decided I was going to do things a little differently from my mother's way. I believed that if I did things differently, I'd get a different result. After all, it's an extremely foolish person who continues to do the same exact thing, time after time, and expects a different result. However, I ended up in the "ditch" on the other side. I was a super-submissive wife.

I believe that the Bible teaches that wives should totally submit to their husbands as long as it does not violate or cause defilement to the Word of God. So there's nothing wrong with being a submitted wife, but there is a lot wrong with being an abused wife.

I had always gone to church as a child; my father and mother made sure of that. After graduating from college, getting married, and starting a family of my own, I naturally attended church with my family. But on the third Sunday afternoon in March of 1971, God visited me in a very unexpected but real way. He talked to me in my kitchen for three hours in a way I didn't know existed. That was the day I received the prophetic mantle, and my life has never been the same.

I began teaching a women's Bible study at my local church. Before it was over, they moved my class out of our room to the main sanctuary. This little women's Bible study group grew to over five hundred strong. There were women and men coming on a regular basis. There were even pastors from other churches attending my meetings and then going back to their churches teaching what they had learned.

While life appeared to be wonderful on the outside, our home wasn't so happy on the inside. I had five children, the most wonderful blessings of my life. My children were always dressed in the latest fashions, attended private schools, participated in extra curricular activities, and we lived in wonderful surroundings. My entire family had active social lives.

However, inside, there was a dirty little secret that would eventually destroy what we had. At a time in American history when we were unfamiliar with the term "domestic violence," the very man who had promised to love, protect, and honor me was ripping apart my very soul. I lived the life of an abused wife and kept the abuse hidden for years.

I understand what abused women go through at the hands of the person they have vowed to love. I understand the barrage of questions that continually go through your mind, beginning with "What did I do to deserve this?" and ending with "Why doesn't my husband love me?" I have experienced what it feels like to have your self-esteem dwindle down to nothing because the words that come at you on a daily basis aren't nurturing or uplifting. I know what it's like to live in the very core of shame while trying to protect your children, your lifestyle, and the individual inflicting the pain. I know all of the degradation that goes along with sexual abuse, even to the point of crawling into the shower, allowing the water to run for what seems like an eternity, and still not feeling clean.

After I had endured all that I could and gone through the humiliation of divorce, God told me to keep my mouth shut. No matter how badly I wanted to say something, I had to discipline my

flesh to keep my mouth shut. I especially couldn't tell my children; he was still their father. We had created this situation, and I refused to allow my children to carry what didn't belong to them.

My children were already dealing with the stigma that goes along with divorce. They had to deal with their mother being a prominent national conference speaker who was being called upon more and more to preach around the country. They had to move out of their home and live with friends for a while until we could figure out where we were going. Through it all, God told me to keep my mouth shut. And I did. I'm not saying you should stay in your bad situation and continue to take the abuse. I'm saying I still had a family, and I had to protect my children at all costs. As they got older, they began to see things and ask questions. I would only say what the Lord allowed me to say. That enabled God to handle things that would crop up later in life because of what I had gone through with their father.

Just because they were our children, a part of us, a part of our family, did not mean that they had to know everything that went on between their parents. I'll say it again: It is an abomination for a woman to uncover her husband, especially in front of her children. No matter what, they are still a part of both of you.

D.I.V.A., at all costs, you must rise above all self-satisfying desires and with the help of the Holy Spirit, do what's right in the sight of God and those who are watching your life. You've got to get back to the place where God always intended for you to be. I'll be honest with you: this won't be easy, but God never asks us to do anything He has not already equipped us to accomplish. Then we will see our dreams come to pass.

Recipe for Deliverance

As you develop the D.I.V.A. in you, it is very important for some things to be set right. Believe me when I say this is not the kind of thing that is spoken of in every forum. But remember, I

told you we would do everything decently and in order, and in the end no one will be upset but the devil. God is the Restorer of our soul, and when we put ourselves in His hands He makes us stronger than we ever imagined.

As we all know life is never easy for any of us. And it gets even more complicated when doors are opened outside of God's will for our life. One such door is that of sexual impurity. Whether it happened through incest, molestation, rape, or promiscuity, our body reacts in ways that we are not equipped to handle on our own.

Once these doors are opened and certain desires have been activated, only God can make things right again. A mother in Zion passed on this recipe and instructions to me long ago. She knew that prayers and the Word of God would strengthen the spirit and renew the mind. But for complete restoration you would have to put your body back into the hands of the Master Creator. This recipe will clean any sexual impurities.

You will need a bottle of anointing (blessed) oil and white vinegar. You're going to do this for fifteen nights. Let this be the last thing that you do at night during this time. You're going to take a sitz bath. Fill your bathtub with enough water to cover your hips and buttocks. The water should be as hot as you can stand it. Add absolutely no bubble bath, bath beads, or salts. Pour in some of the oil and vinegar. Get in and sit with your legs apart and your knees raised for fifteen minutes. Afterwards do not bathe; just get out of the tub and dry off. You may bathe in the morning.

This is a time of consecration to God and restoration for you. God is able to restore all things back to you no matter what you have gone through. Trust in Him and know that He will make everything right for you again.

CHAPTER 3

Speak to That Mountain

Satan Always Comes Against Prophecy

…and let them have dominion… (Genesis 1:26).

GOD ORIGINALLY PLACED ADAM IN the garden with power, authority, and dominion over all the works of His hand. We don't actually know how long Adam was in the garden studying, categorizing, and naming all the animals, plants, and trees. He had to watch their character and behavior to know exactly what each creature did so he could name them. All the while Adam was doing his job, we never hear one word about the devil. Although the devil was there all the time, the Bible never mentions him. Adam was safe and secure, doing his job and communing with God.

It wasn't until he, Adam, became "them," Adam and Eve, that we first hear about the devil. This is because it wasn't until Adam and Eve were together that the Word God had spoken over them

was activated. Now they would have dominion—and here comes the devil to mess things up. So it's only after Eve's arrival that we first hear of satan.

Let me tell you something about your own life. When some of you were in those dead churches, the devil didn't bother you. He didn't start to bother you until you came into your existence in God. He didn't bother you until you began to stir up the Holy Ghost and the gifts that were lying dormant on the inside of you. He didn't bother you until you started to know who you were in Christ. So, just like in the garden, the devil has been there all the time, but you've never given him a reason to rise up and strike you until now.

The reason the devil began to strike Adam and Eve was because he recognized something that we often refuse to see. It's called the Word of God. The devil remembered the prophecy. As long as Adam was walking around and "them" was hidden in him, Adam wasn't a threat to the devil. The devil knows that God is going to always do exactly what He says He's going to do. God said He would bless "them." He would give "them" dominion. God told "them" to subdue. As long as there was no "them," the prophecy couldn't come to pass. So as soon as Eve showed up, "they" showed up, and the devil got busy, because now he wanted to stop the prophecy. The devil knew the prophecy couldn't be fulfilled until you, the woman, came on the scene. The prophecy wasn't complete until there was you.

Let me ask you something: What prophecy has been spoken over your life that you haven't seen come to pass? Or what promise have you read in the Word of God that you're believing God for that hasn't come to pass?

I know beyond a shadow of a doubt that once you have latched on to the validity of your promise, the devil will pull every trick out of his bag of deception to try and get you thrown off course.

When this happens, all you have is the Word of God to stand on until you push the enemy back and your promise manifests in your life.

So when satan began questioning Eve about what God said, she should have taken dominion right there and stood her ground, but she didn't. She started to dialog with the enemy on his turf, and she lost. Therefore, whatever Word of God you're standing on, no matter how the enemy comes at you, hold your ground. It's the mature D.I.V.A. who holds on until breakthrough comes. It's the immature person who throws in the towel at the first sign of trouble.

Even if everything seems to be quiet on the home front now, this would be a good time to begin to gird yourself up, because the enemy won't be lying dormant for long. He's coming to try and displace you from where God has called you to be.

Placement versus Displacement

Through faith also Sara herself received strength to conceive seed, and was delivered of a child when she was past age, because she judged Him faithful who had promised (Hebrews 11:11).

And when the woman saw that the tree was good for food, and that it was pleasant to the eyes, and a tree to be desired to make one wise, she took of the fruit thereof, and did eat, and gave also unto her husband with her; and he did eat (Genesis 3:6).

Here we have two women: Sarah and Eve. One was driven from her place of destiny because of the choices she made. The other chose to judge God faithful and remained in her place and completed her destiny. They were both destined to become first or to be pioneers in the respective calls on their lives. Eve was the first mother of mankind, and Sarah was the first mother of faith. Both women knew God through their husbands, but both would discover for themselves that the God they served was a very personal God and the choices that they made, concerning the things of

God, would affect not only them but those around them and generations to come.

Unlike Eve, the twenty-first-century D.I.V.A. is a woman who is learning how to make wise decisions and reach her destiny. She's also a woman of strength and integrity. She's able to look past those things that are "good…pleasant…and to be desired," and she's able to get past the desire to satisfy her flesh.

Eve, the mother of mankind, knew what God said about the tree of the knowledge of good and evil, but she disobeyed anyway. She knew the rules because she discussed them with the devil before she sinned.

> *Now the serpent was more subtil than any beast of the field which the Lord God had made. And he said unto the woman, "Yea, hath God said, 'Ye shall not eat of every tree of the garden?'" And the woman said unto the serpent, "We may eat of the fruit of the trees of the garden: But of the fruit of the tree which is in the midst of the garden, God hath said, 'Ye shall not eat of it, neither shall ye touch it, lest ye die.'" And the serpent said unto the woman, "Ye shall not surely die: For God doth know that in the day ye eat thereof, then your eyes shall be opened, and ye shall be as gods, knowing good and evil"* (Genesis 3:1-5).

Eve allowed herself to be deceived and did what God specifically said not to do. This, in modern-day vernacular, opened the front door and invited the enemy right into her living room.

She began by reasoning with the enemy about what God did and did not say. The arena of reason is the devil's turf, and no matter what you think, when you come up against him in this arena, you will always lose. Once Eve had it made up in her own mind, she was able to discount everything she had been taught and did what felt good instead of obeying God's instructions. So, God has stated unequivocally that He is getting rid of the spirit of Eve from among His women.

D.I.V.A., you must understand that no matter how many different ways we reason through something, "no" still means "no." When someone tells you not to touch something, it means do not put your hands on the thing. Instructions from God, your husband, church leaders, and those in leadership over you on your job are still instructions that must be followed.

We must put away rebellion and reach the point where we trust God and everyone else who has authority over us enough to accept instructions and move on. Just because no one had ever experienced death at that time doesn't make God's directive any less effective. This is an issue of trust and obedience for those who want to walk in the glory, blessings, and protection of God.

Sarah, the mother of faith, reached her destiny. She was able to look past what her eyes beheld to latch on to the promise of God. Her life demonstrates to us that no matter how things look to the natural eye—be it good or bad, old or young—God can be trusted.

It took a lot for Sarah to get to the point where she could see herself the way God saw her. But we all know she got to that point. She conceived and gave birth to the very thing that she and her husband wanted: a child, a legal heir to the family fortune.

What is it going to take for you to get to the point where you see yourself the way God sees you? Right now, God sees you as a D.I.V.A. In His sight you are a Divinely Inspired Virtuous Asset. Now you can jump on board and see yourself the way God sees you, or you can rebel against God's purpose for your life. Let's mature to the point that we are able to trust in the Word of God and be obedient when God speaks to us.

And Samuel said, "Hath the Lord as great delight in burnt offerings and sacrifices, as in obeying the voice of the Lord? Behold, to obey is better than sacrifice, and to hearken than the fat of rams" (1 Samuel 15:22).

We hear this over and over again: "Obedience is better than sacrifice." Eve sacrificed her future to satisfy her flesh. Gratification that lasts for only a moment and is then eliminated can't compare to missing your destiny.

Sarah, on the other hand, pushed past what she beheld with her eyes, latched on to the promise of God, and received the manifestation of that promise into her life. It will only be through your obedience to God's purpose for your life that you will remain in the place you were destined to be and receive your promise.

CHAPTER 4

Different Than Is Not Better Than

The Nurturing Nature of God

I TOLD YOU IN THE BEGINNING, if you would hang in there until the end, nobody would be offended except the devil. The reason he's offended is because you're learning things that expose him for the manipulative, lying deceiver that he really is.

I'm sure that after everything you've learned thus far, you've begun to experience the worth of a true D.I.V.A. But we're not finished yet, and I would suggest you hold on to your seats because the ride is about to get a little bumpy. In fact, if there were a ratings system for this portion of the book, it would receive a "M" for mature subject matter. I'm not talking about for adults only, because becoming a D.I.V.A. begins at birth. What I am referring to is that this is for those of you who are mature enough to handle what you're about to learn.

Men and women experience a lot of the same things, but there are two areas that only women can relate to. I believe that once you

get an understanding of these two areas, you'll look at your body, your life, and your purpose differently. Let's go back to the beginning, back to the garden, back to Adam and Eve.

Before Adam was put to sleep, everything looked masculine: Adam, God the Father, God the Son, the Holy Spirit, and the angels. Then God put Adam to sleep, and when he woke up, there was something looking back at him that didn't look masculine in any way, shape, or form. As a matter of fact, the new thing had long hair and curves, something Adam had not seen before. When the new thing walked, everything moved differently; it sort of softly swayed from side-to-side. And to top it off, Adam liked what he saw.

Now, putting all of the subtle differences aside, there was one difference that you couldn't miss even if you tried. This new thing had some things sticking out in front that Adam had not seen before. You know he had to have been wondering, "What are they, and what are they for?"

This is something that had been hidden in God. El Shaddai—the Many-Breasted One—had come into the garden. Comfort and all its attributes had now come into the garden. In the beginning there had been the power of God; now there was the comfort of God. In the beginning there had been the authority of God; now there was the mercy of God. In the beginning, there was understanding to do things; now there was grace and patience to endure until the thing was complete.

A lot of us are unfamiliar with this part of God's character. We don't know what it's like to be comforted when we make mistakes. We don't know what it's like to be restored back to wholeness. We don't know what it's like to be nurtured until we can see the light of day in our situation. We certainly don't know what it's like to feel safe because mercy and grace are following us every single day. We don't know how to lean back on El Shaddai—the Many Breasted One—and receive what He's trying to impart into our very being.

This part of God's character was placed in the woman. Now that some light is shining on the purpose of this part of the female anatomy, you're beginning to think a little differently about how you view this part of your character. That's right—not just your body but your character.

This part of you is not something to be perverted but something to be understood, cherished, respected, and prayed over. Think about it: God chose you to bear this responsibility, and it's an awesome thing.

I know you can see now why the enemy has fought so hard to pervert your way of thinking about this part of your body. The enemy wants you to think that allowing anything to come along and touch or lie on your breasts is all right. We see this in our everyday lives. Most women have no understanding of what their breasts are for, and when you don't know the purpose of a thing, you will abuse it.

The entertainment industry has deceived us into believing that it's all right to expose ourselves: "No harm, no foul." Advertisers have programmed us into believing that the only way for them to sell their products is by women exposing their breasts.

We as Christians buy into this foolishness because we don't understand that our breasts represent the very nurturing mercy of God. This part of God's character didn't exist in the earthly realm until the woman showed up in all her fullness.

However, in our perverted way of thinking, we refuse to honor what God has given us. Instead, we're fixated on our breasts being too large or too small. I know to some that has got to be one of the craziest things under the sun. But it is so real for those who experience this fixation that it consumes their every waking moment.

It is so real to them that they would undergo surgery to have implants to make their breasts larger or reductions to make them smaller. There are medical reasons for these surgeries. However,

when women are having surgery just to "get a man" or to help them feel better about themselves, I believe they have crossed the line.

This all stems from inferiority and rejection. We must stop allowing negative pictures of ourselves, planted by those who have negative pictures of themselves, dictate our actions.

Breast cancer, or the fear thereof, is another area in which the enemy is trying to pervert God's purpose for our lives. For some women, there is such a fear of breast cancer because of their family history, they are willing to have their breasts removed "just to be on the safe side." This fear is also running rampant through the Church. The women of God are being hit like never before. Now you can understand why.

D.I.V.A., because you were given breasts you possess the very essence of God that nurtures. This goes beyond you physically nurturing your children or comforting them when they are scared or hurting. This also extends to your husband when he is scared or hurting or can't figure out how to pay the mortgage next month. You can go to him with the comfort of God that you possess, that will lift him up from where he is to where God wants him to be.

Now you can understand how valuable you are and how valuable your body is. Now that we have begun to build a foundation, we're not just going to stop here. You're going to learn how to guard your body and how to protect it from the onslaught of the enemy. You're going to learn how to lay hands on it and speak the Word of God into it. You're also going to learn how to bring sanctification back to it.

We're not finished yet. There is still one more part of the body that only women can relate to.

The Matrix—Legal Entry

All that openeth the matrix is mine; and every firstling among thy cattle, whether ox or sheep, that is male (Exodus 34:19).

To understand the other part of the woman's body that is different from the man's, you must first understand its purpose. It's called a matrix; it has a door, and it acts as an incubator. Webster says a matrix is something within which something else originates or develops.

Hidden deep inside the woman is the capability for the development of all human life. God placed this matrix deep inside the woman. The opening or door was hidden from sight. It has always been a mystery to most of the world until now.

> *If she be a wall, we will build upon her a palace of silver: and if she be a door, we will inclose her with boards of cedar* (Song of Solomon 8:9).

The door or opening to the matrix was placed between the woman's legs. This door, just like any door, has the ability to be opened wide or closed tight. How is it opened?

> *My beloved put in his hand by the hole of the door, and my bowels were moved for him* (Song of Solomon 5:4).

If you're married, you can understand what I'm saying. Whenever a man wants to get through a door he first uses his hand. The hand goes to open the door before the other parts can come through.

Open your Bible and read it for yourself. This is not something I made up. "His hand" went to "the door," and her "bowels" started to move. That's because if the hand is the right hand, ordained of God and sanctioned by marriage, and this hand knows how to work the door, everything inside of you will start to move. So, yes, marriage is the only way to legally open the door and enter the doorway; any other way is illegal.

Since this is a doorway and we now understand how it's opened and what can legally go through it, we must also understand that a deposit is made, a seed. The deposit and the seed brings us back to our definition of the matrix—something within which something else originates or develops.

Once the seed is deposited and develops, it comes forth in the fullness of time: a brand new life—a new life with potential, purpose, and destiny, a new life that was sanctified and approved of by God before it was ever placed in the matrix or womb.

D.I.V.A., you don't know who God wants to bring through your doorway. However, all you have to know is that greatness has been preordained and destined to come through your doorway. Therefore, you had better be careful of those illegal hands. You'd better keep what's unlawful away from your doorway. Always remember that what opens the door and enters must be legal so that what comes out will be legal.

> *Verily, verily, I say unto you, He that entereth not by the door into the sheepfold, but climbeth up some other way, the same is a thief and a robber* (John 10:1).

The devil was cast out of Heaven for rebellion. His final destination was earth. He didn't enter through a door; therefore, his entry was illegal. Everything satan has—power, ability, dominion, rule, authority—none of it belongs to him because he's a thief. Everything that he has stolen has to be returned to the rightful owners.

Now, while all of this stealing, killing, and destroying was going on, God had already set in motion a legal way for man to regain what had been stolen. God is God, and He could have come in and simply taken it all back. But it wasn't stolen from God, it was stolen from man. Therefore, a man had to reclaim it. The only way for that to be accomplished was for a member of the Godhead to take the form of a man and come through the legal entryway. By coming through the legal entryway, He was coming with legal authority—the very same authority that Jesus gave back to mankind on the cross.

Now we understand that any time God wants to do something, He has to come through a door. The seed is planted in the matrix or womb, incubated for a period of time, then birth takes place: life comes through the door.

This is why the devil is always trying to close your door. It starts in childhood through incest and molestation. Then it goes into the teen years throughout adulthood with promiscuity. The enemy is trying to get you to sleep around with as many different men as possible; he is trying to close your door. Rape is another area the enemy set in motion in an attempt to close your door. Abortion is another area of deception set in motion to try and close your door.

All of this has programmed our minds to hate men. Many women grow up believing that men are the enemy. Without understanding from the Word of God, we will buy into that lie and live in deception the rest of our lives. It's satan who is the enemy, and in his own subtle way, he's trying to close our doors and make us ineffective.

Something so beautiful and wonderful as sex, which was ordained and given to us by God to be shared only between a husband and wife, has been misunderstood, misused and abused since Adam and Eve were banished from the garden. And it's up to us, with the instruction and help from the Holy Spirit, to put this thing back in proper order.

The Apostle Paul said, "But I keep under my body, and bring it into subjection: lest that by any means, when I have preached to others, I myself should be a castaway" (1 Cor. 9:27).

Sex and sexual desires are a natural part of the human experience. We've already established that it is only legal for those in the marriage covenant. So, D.I.V.A., if your door has been opened, no matter what the circumstances, and you're single, we're going to close your door. This doesn't mean that these desires won't rise up in you, but it does mean that you understand they are illegal for you. Once something breaks the law, it must be arrested and dealt with immediately. You must take a stand for righteousness, and when the desire comes against you, you simply reply by saying, "God, it came on me, but it's got to go; everything that comes that does not pertain to life and godliness has to

go. God, I'm not married, and that's for the covenant of marriage so, therefore, it's not allowed to come my way. It is illegal, and I refuse to allow it to come my way."

It's a want you're not allowed to have. It's trying to make an illegal entry through the door. Remember: we don't know what God wants to bring through the door, so we can't allow just anything to mess around the door.

I remember when God told me that He would sanctify my womb again. I said, "God, I've been so violated I didn't ever think it could be sanctified again." But He did it, and He's no respecter of persons. If He did it for me, He'll do it for you. He just came in and did it by the power of the Holy Ghost. He can make you pure again.

When it was time for Christ to be born, God didn't go to the Sadducees, or the Pharisees, or the religious sects. He went to the matrix or incubator that had a door; her name was Mary. For nine months, the Holy One of Israel, El Shaddai—the Many Breasted One, the All-Sufficient God—was growing in the womb of a woman. For nine months, He was taking on fingers and toes and being developed. Can't you see why the devil wants to make you feel ineffective? Why he tries to get you to sleep around, then not value yourself? The devil wants you to believe that God could never give birth to anything through you because you've been violated or because you've allowed defilement to come. You're always thinking God can use other people, but He could never use you.

This is the very reason I'm writing this book. I'm one of you. I've been defiled, and I've made bad choices. But God sanctified me and made me new. He cleansed me, washed me, and gave me the ability to give birth to things. You have that same ability inside of you. You just have to let God restore and sanctify you again.

IMPARTATION II

Inspired

Inspired

D.I.V.A., IN ORDER FOR YOU TO LIVE YOUR life as a Divinely Inspired Virtuous Asset, you must now rethink your understanding of what inspires you. You may think that you know what being inspired is all about—well, I don't think so.

I know that inspiration makes you feel good and may even challenge you to go to the next level in God, but that's not what I'm talking about. I'm talking about when you're inspired by God.

The word "inspire" means to draw forth or bring out. But the word God gave me was "Inspired"—past tense. So to be inspired by God means that you're going to allow God to go in and draw forth or bring out of you the thing that He put in you before you were placed in your mother's womb.

When God inspires you, He tears down your old way of thinking. Then He breaks up the old foundation that all of your old habits and ways were built on and cleans you up. He then lays a

new foundation, pulls out everything that He placed in you (all the good stuff) and equips you with everything you'll need for success.

So, we're not looking outside for inspiration. We're going to build on what's already inside. And the foundation that's being built will support everything that's beginning to stir on the inside of you. I'm talking about the very thing that you were meant to do in the earthly realm.

What I've been sent to do is help equip you for the journey. Before God can pull anything out of you, He must first remind you of what He put in you. See, if He went in there and began pulling things out, good things, you'd fight Him every step of the way. This is unfamiliar territory to you, and you know we always fight what we don't understand.

Whatever God put inside of you is good, and you're about to remember what it is you're good at doing. Then you're going to learn how to develop it and how to stay focused on it. You're going to walk in the very success that you were always meant to walk in. Remember, these are not just words. I've lived this thing, and it worked for me, so I know it will work for you also.

CHAPTER 1

Behind the Veil

Before I formed you in the womb I knew [and] approved of you [as My chosen instrument], and before you were born I separated and set you apart, consecrating you; [and] I appointed you as a prophet to the nations (Jeremiah 1:5 AMP).

WHEN ADAM AND EVE DISOBEYED God's instructions and ate from the tree of the knowledge of good and evil, sin entered into what had been a perfect environment. Sin threw everything out of order and brought separation to the Creator and His creation. The original intent of the creation was lost—not to the Creator, but to the creation. The Head was now separated from the body.

It's a freakish thing to see a body without a head attached, but that's what the creation had become. It was lost, wondering why it had been created, unable to get back to the place of understanding and security that can only be found in the Creator. The sad thing is that what the creation had been looking for wasn't lost but hidden

deep inside of it all along. See, inside of you is the ability to remember what you were created for. We're going to jog that memory so that you can shake off everything else and walk out your purpose in God.

What I'm talking about is right inside of you, encapsulated in you, inside of your memory. You're going to remember who you were and what you were meant to do before you were placed in your mother's womb. God wants to restore to you the memory you had of being a success in Him, the memory you had before the enemy of your soul, circumstances of life, and a lot of bad choices came along and stole it from you.

God is saying, "It is time for each member of my body to remember why I placed them on the earth." When you get a glimpse of what you are supposed to do—your purpose—you will walk in it regardless of what's going on around you.

> *Verily, verily, I say unto you, He that believeth on Me, the works that I do shall he do also; and greater works than these shall he do; because I go unto My Father* (John 14:12).

This is not a suggestion. It is more of a directive from someone who knew that He would go to the cross and ultimately die for the very people who would reject Him. You'd think that He would try to get out of His assignment, but He didn't. He was determined He would finish His race.

Before Jesus ever went to the cross, He knew who He was and what He was put here to do. He walked out His purpose and left an example for us to follow. In fact, Jesus not only finished His course, He did it with joy.

> *Wherefore seeing we also are compassed about with so great a cloud of witnesses, let us lay aside every weight, and the sin which doth so easily beset us, and let us run with patience the race that is set before us, looking unto Jesus the author and finisher of our faith; who for the joy that was set before Him*

endured the cross, despising the shame, and is set down at the right hand of the throne of God (Hebrews 12:1-2).

Have you ever stopped to wonder how Jesus could endure the cross with joy? Jesus got joy in the fact that He would reconcile mankind back to God, and that gave him the strength to endure the cross. After all, the joy of the Lord is our strength.

Knowing that He would only live on earth for a short time, Jesus still fulfilled His purpose. Knowing that He was going to Calvary, He still ran His race. Knowing that He would be tortured, He never turned from His destiny. And no matter what your circumstances are, you will fulfill yours!

Jesus' entire life was designed to take Him to Calvary. Even at birth, the wise men came to give honor to the Savior. They brought gifts that represented who He was and His purpose in this life. They presented Him with gold, frankincense, and myrrh. The gold was a gift for a king, frankincense was for His deity, and myrrh was used for embalming a person after death.

Why bring myrrh to a newborn who's just starting life? Because he was born to die. That was His destiny. Even as a small child, it was established that Jesus was a king, meaning He was all man. He had deity, meaning He was all God. Finally, He would die. None of that deterred Him from His purpose because it was always, constantly, in front of Him.

From that time forth began Jesus to shew unto His disciples, how that He must go unto Jerusalem, and suffer many things of the elders and chief priests and scribes, and be killed, and be raised again the third day (Matthew 16:21).

For He taught His disciples, and said unto them, "The Son of man is delivered into the hands of men, and they shall kill Him; and after that He is killed, He shall rise the third day" (Mark 9:31).

And they were in the way going up to Jerusalem; and Jesus went before them: and they were amazed; and as they followed, they were afraid. And He took again the twelve, and began to tell them what things should happen unto Him, saying, "Behold, we go up to Jerusalem; and the Son of man shall be delivered unto the chief priests, and unto the scribes; and they shall condemn Him to death, and shall deliver Him to the Gentiles: and they shall mock Him, and shall scourge Him, and shall spit upon Him, and shall kill Him: and the third day He shall rise again" (Mark 10:32-34).

Jesus answered and said unto them, "Destroy this temple, and in three days I will raise it up" (John 2:19).

There wasn't a chance that Jesus could get off track or lose sight of His purpose because He continually kept His purpose before Him.

I want you to think back to when you were a small child. Can you remember what it was that you liked to do the most? Can you remember what you spent your time thinking or fantasizing about?

The best illustration I can give is that back in the 1950s and 1960s I had it in me that I was going to be Miss America. I used to walk around practicing my smile and my wave just like I saw them do on television. Even though there weren't any black girls in those pageants back then, I still saw myself walking across a stage and wearing long, flowing dresses; and they always had something dripping off of them.

I was preaching once in this sanctuary that had a very large elaborate stage. I noticed there were tons of people as I walked across the stage, and I had on a long, flowing dress.

The Lord reminded me of the vision I had of myself as a little girl and what I had thought. I said, "This isn't Miss America. This isn't a pageant. I'm not a queen. What's going on here, God?"

He said, "No, it isn't Miss America, but I placed that in you. I placed in you that you would stand before people and that you would

walk around in beautiful clothes with something dripping off you. It is the anointing! That's why you walk all the time. You can't preach a sermon standing still because that's the vision I placed in you.

"However, there was nothing there to feed the vision. The only thing you ever saw walking across a stage on television in front of a bunch of people was Miss America, so that's what you related it to and that's why it feels so right to you now."

As a small child I had that thought embedded within me, and no one could take it out. Now it's just manifested in a different way, the way God had preordained it to manifest from the beginning. Now I'm walking in what I saw as a small child. What did you see yourself doing as a small child?

There's a woman in my church right now that as a small child, she saw herself walking down a long corridor that led into an office where she worked. She grew up and began her family. Then she went to business school. After graduating, the second job she got had a long corridor leading to the office where she worked. She never forgot the vision God placed in her heart. She spent twenty years on that job before retiring. In all that time, she obtained the skills that she would need to run her own business. Now she's about to see another vision manifest in her life.

The very thing that God has put in you is what He wants to pull out of you now. Just ask Him to bring it back to your remembrance. You probably don't have to ask God because you've never forgotten. That thing has been eating away at you for years, and you didn't know that it was God or how to satisfy all of the unrest on the inside of you.

A lot of times the unrest that you feel will cause you to try and get answers for what's going on inside of you from the people around you. However, it never fails; the people that you reach out to will be the very people who see it as their sole purpose in life to let you know how crazy you are. They will kill your dreams with doubt and disbelief.

It's just like when Jesus told the disciples what was going to happen to Him and Peter rebuked Him. How is it that Peter, a disciple, could tell Jesus—who was all God and all man, and knew from birth that His purpose was to die—that things would not happen the way Jesus was expecting them to happen?

> *From that time forth began Jesus to shew unto His disciples, how that He must go unto Jerusalem, and suffer many things of the elders and chief priests and scribes, and be killed, and be raised again the third day. Then Peter took Him, and began to rebuke Him, saying, "Be it far from Thee, Lord: this shall not be unto Thee." But He turned, and said unto Peter, "Get thee behind me satan: thou art an offence unto me: for thou savourest not the things that be of God, but those that be of men"* (Matthew 16:21-23).

We all can learn a lesson in this. There's always going to be someone in place to come against what God has preordained for your life. But instead of listening to what they have to say, you must do like Jesus and open your mouth. You'll have to take a stand and counter their words with the truth before their negative words have a chance to take root and you begin to doubt what God has told you.

Back in the 1970s, when my first two children were very young, I was teaching them the Bible. The Lord told me to design puzzles, using Bible stories, that would help them learn on their level. He told me to make them out of large pieces of wood so the children would be able to handle them easily. My babies were already playing with puzzles, so why not let them play with something that would make a lasting impression on their eternal souls? I mentioned this to two other people, and they mocked me. They said, "You've gone to being a fanatic with this Bible stuff. Who do you think is going to buy a puzzle about Bible stories?" My dream died.

> *Enter ye in at the strait gate: for wide is the gate, and broad is the way, that leadeth to destruction, and many there be which go in thereat: because strait is the gate, and narrow is the way,*

which leadeth unto life, and few there be that find it (Matthew 7:13-14).

Once you begin to strive toward your purpose in life, there are always more people to come against what God has deposited in your heart than there are people to support you. God has people in place to support you. However, you must persevere with patience and God will reveal them to you.

An important thing to remember is that when you learn that you're gifted, you can't expose every aspect of the gift to other people. You can't release what's on the inside of you ahead of time because it will never come to fruition.

From now on, you're going to hold on to what God shows you until He says it's time to release it. Not only will most people not support you, but a lot of them will try and stop you if you allow them. But you're no longer going to allow that to happen.

Re-membered

In order for the memory that you have now to be activated to work for you, you must be rejoined to the Head of the body: God. Adam's disobedience caused the door to be open to sin. Whenever sin enters, a separation or dismemberment always takes place. Jesus came to bring fallen man back to God, to reconcile them. This reconciliation began with Jesus' birth and ended at Calvary.

Historians say that when Jesus was on the cross, there were nails in His wrists and ankles. Remember when Jesus went to the cross, He was all man. With His arms outstretched on either side of Him, the weight of His body pulled downward. When the pain became unbearable and He needed to get air to His lungs, He would push Himself up against the nails in His ankles, realigning His respiratory system so He could breathe. Then when He could no longer hold himself up, the weight of His body would pull Him down again. With all of this up-and-down motion, His body was slowly being separated or dismembered.

None of His bones were broken; we know that from Scripture, so we cannot be broken. However, He was completely dismembered with everything being pulled out of place. He took the dismemberment in His body so that we didn't have to take it in ours.

On the day that Jesus was crucified, there were two criminals hanging on either side of Him. One said, "Lord, remember me when thou comest into Thy kingdom." Jesus responded, "Verily, I say unto thee, Today shalt thou be with Me in paradise." He wasn't asking for Jesus to mentally remember Him but rather to re-member Him, to join him back to the Head. We can ask right now to be re-membered to the Head, which positions us for destiny. The criminal was pre-destined to show that it's never too late for repentance, salvation, or to be connected back to God and your destiny.

You may be afraid, thinking this is a hard thing. However, Jesus suffered in a way that we will never understand. Nothing on earth can prepare anyone for what they are going to suffer for the sake of the gospel. We've already read that Jesus did it with joy. For most of us, when hard times hit, we're ready to give up because we lose focus and can't see the joy set before us. So it's probably safe to say that it has never dawned on you that the suffering that you're going through is proportional to the joy that is set before you.

Jesus not only took our place, but He suffered for all those who had gone before Him. He suffered for all those who would come after Him. He suffered for all mankind. Now He's seated at the right hand of the Father on high. There is no man who is His equal. His joy is proportional to His suffering. If you will just hang in there, yours will be, too! It won't be equal to what Jesus went through and what He's enjoying now. But your joy will be proportionate to what you are going through.

Now that you've remembered your purpose in God and can put all of your dismemberment under the blood and walk out God's original purpose for your life without hesitation, it's time for you to learn how to feed, fertilize, and water that purpose so it can come to fruition.

CHAPTER 2

God's Purpose for Your Life

For I know the thoughts that I think toward you, saith the Lord, thoughts of peace, and not of evil, to give you an expected end (Jeremiah 29:11).

The Rewards for Purpose

NOW THAT IT HAS BEEN ESTABLISHED that you do indeed have a purpose, I'm going to show you how to develop it. You're going to get rid of the spirit of procrastination and prioritize yourself so that you can walk out your destiny.

I want to tell you something prophetically: Everyone working in this move of God is going to get a reward. We have worked in other moves and haven't seen our reward. However, everyone working in the Father's business is going to get a reward. I don't mean when you get to Heaven but in this dispensation. The reapers are going to get paid. Those who are doing what they are supposed

to be doing, what God has told them to do, are going to get blessed. This is not the time for you to be uncertain, unclear, unsettled, or indecisive about what you are called to do. You need to know where you're supposed to be and what you're supposed to do so you can receive the blessing God has designated for you.

Once you find God's purpose for your life, it will bring you peace, joy, fulfillment, and provision. You'll never have these things until you find your purpose and begin to fulfill it. Let me ask you: Do you believe that the job you're on is directly related to your purpose in God? Do you believe that your present job is grooming you for the call that God has purposed for you on earth? Or are you just getting up, spending eight hours or more every day, and being miserable? If you're supposed to be a school teacher, then that school teacher's position will bring peace, joy, fulfillment, and provision to your life—that is, if God called you to be a school teacher before the foundation of the world.

I can tell you unequivocally that preaching the gospel brings me peace, joy, fulfillment, and provision. I can tell you unequivocally that my needs are always met, and sometimes I can't even figure out how it happens. No matter what is going on in my life, my needs are always met because I'm doing what I was called to do before the foundation of the world. I'm right smack-dab in the center of God's will for my life. I'm not saying that I never have challenges, because I do. However, I still have peace, joy, fulfillment, and provision.

The Anointing Is in the Instructions

First, in developing your purpose, you must do something that is fairly simple. However, it trips up a lot of people. You'll have to learn to follow instructions. You've got to learn to follow God's instructions without questions, fear, or hesitation. A good example of that would be the instructions God gave to Moses for the building of the tabernacle.

Thou shalt also make a table of shittim wood: two cubits shall be the length thereof, and a cubit the breadth thereof, and a cubit and a half the height thereof. And thou shalt overlay it with pure gold, and make thereto a crown of gold round about. And thou shalt make unto it a border of an hand breadth round about, and thou shalt make a golden crown to the border thereof round about. And thou shalt make for it four rings of gold, and put the rings in the four corners that are on the four feet thereof. Over against the border shall the rings be for places of the staves to bear the table. And thou shalt make the staves of shittim wood, and overlay them with gold, that the table may be borne with them. And thou shalt make the dishes thereof, and spoons thereof, and covers thereof, and bowls thereof, to cover withal: of pure gold shalt thou make them. And thou shalt set upon the table shewbread before me alway (Exodus 25:23-30).

Every D.I.V.A. should understand that God's instructions are always specific. In this passage of Scripture, God didn't leave anything to their imagination or earthly know-how. You may know how to do a thing, and that's fine, but when God gives instructions, He may give them a little bit differently than the way you're used to; you should always stick to God's instructions.

God specifically says, "And thou shall make for it four rings of gold." When you hear four rings, just make four rings, not three or five. When you hear gold, just use gold, not silver or bronze. Can you please get to the point that you believe that the instructions of God have validity? It will help take the weight off your mind if you could just receive instructions and not try to figure them out or change them.

God is not developing robots. He's not developing people who can't think for themselves. However, He must have people who can follow instructions. He's got to have people who, if they receive instructions to take four steps forward then turn right,

will follow those instructions without questioning them or trying to change them.

In this move, if you were to go five steps instead of four and you were to turn left and God said turn right, you could end up in a situation that you're not prepared to handle. Missiles have been released by the enemy with your name on them. If you go through with the wrong instructions, those missiles are going to hit you just like you are a target lit up with a bull's-eye right in the middle of your belly.

Then you're left blaming God and wondering why it came on you. Because the anointing is in the instructions and you refused to follow the instructions, you're going to be the one who gets hit. Your protection is wrapped up in you following the instructions. If you would just follow them the way that they were given to you, that problem would just go sailing right on past you.

I'm telling you this because we don't have time to put you back together again if you fall apart because you refused to follow the instructions. We don't have time to pick you up and pacify your flesh. Unlike times past, mature saints are walking up to you and saying, "Shake it off." You'd better shake it off and move on. If not, you'll always be sitting on the sidelines, wondering why other people are getting blessed and why God loves them more than you. That's not what God wants, so you should begin to train yourself to hear and carry out the instructions of the Lord.

Purpose and Prayer

God instructed Moses, "Set upon the table showbread before me alway." You cannot get a clear understanding of your purpose without understanding the purpose of the showbread.

The showbread was unleavened bread that was baked and consumed by the priest every day. Legally, no one but the priest could eat it, and there could be none left over.

Now, the showbread was indeed bread. However, it represented more than just bread. In Greek, showbread means "to set before, to establish before, the intention of, or purpose." So, the word showbread means purpose.

In other words, they weren't just setting the showbread on the table in the tabernacle and consuming it daily, they were setting their purpose on the table in the tabernacle and consuming it daily.

One way for us to consume our purpose daily is to cover it in prayer. Even Solomon understood the importance of covering the showbread or purpose in prayer daily.

> And Solomon sent to Huram the king of Tyre, saying, "As thou didst deal with David my father, and didst send him cedars to build him an house to dwell therein, even so deal with me. Behold, I build an house to the name of the Lord my God, to dedicate it to him, and to burn before him sweet incense, and for the continual shewbread, and for the burnt offerings morning and evening, on the Sabbaths, and on the new moons, and on the solemn feasts of the Lord our God. This is an ordinance for ever to Israel" (2 Chronicles 2:3-4).

In Solomon's request to Huram, he mentions the purpose of him wanting to build God a house, "and to burn before him sweet incense, and for the continual showbread."

The word "incense" represents prayer. What Solomon was saying was he had to build a permanent dwelling place, sanctified and set apart, so that his purpose could go before God in prayer continually. Your purpose must go up before God every day in prayer.

D.I.V.A., there should not be one day that passes that you don't cover your purpose in prayer. Continually presenting your purpose before God leaves the channels open for God to speak to you concerning different aspects of what you should be doing. God can show you ways to implement things that you would have never imagined on your own.

You can go to bed thinking one way about your purpose and wake up the next day with a completely new set of instructions that you've received from God because you chose to keep the prayer lines open daily. After all, it is God's purpose for your life, so allow Him to instruct you.

If you want to do something for the Kingdom of God, you're going to have to use God's instructions, instructions that you receive from Him as you pray daily over your purpose.

Purpose Works for Us

And we know that all things work together for good to them that love God, to them who are the called according to His purpose (Romans 8:28).

You hear a lot of people quoting and claiming this Scripture. However, it only applies to those "that love God, to them who are the called according to his purpose." If you're not doing exactly what God purposed for you to do, you can't claim that things are working together for your good.

If you're on a job just because it's a job and you're getting a paycheck when calamity strikes you—and it will because you're out of place—you can't claim Romans 8:28, because you are not "called according to His purpose." You're actually there doing your own thing.

It's God's purpose that you were put on this earth to fulfill, not your own. This is why it's important to get a clear understanding of God's purpose for your life. You don't have time to waste. Do you want Jesus to come back and you give an account of what you've been doing, and have Him tell you that it's not what He purposed you to do? If I'm not called to preach, then I want to find out what it is that I *am* called to do.

I decided once that I wasn't going to preach anymore. I was going to be a church administrator and work for a pastor, helping

to establish his church. Three people in my city tried to hire me as their assistant pastor. I didn't have a job and had turned down all my speaking engagements, but God wouldn't allow me to accept any of the three positions. He said, "That's not the thing that I purposed you to do. Don't do it." I would not have been in place or consuming my purpose.

Purpose Supersedes Natural and Religious Laws

And it came to pass, that He went through the corn fields on the Sabbath day; and His disciples began, as they went, to pluck the ears of corn. And the Pharisees said unto Him, "Behold, why do they on the Sabbath day that which is not lawful?" And He said unto them, "Have ye never read what David did, when he had need, and was an hungred, he, and they that were with him? How he went into the house of God in the days of Abiathar the high priest, and did eat the shewbread, which is not lawful to eat but for the priests, and gave also to them which were with him?" And He said unto them, "The Sabbath was made for man, and not man for the Sabbath: therefore the Son of man is Lord also of the Sabbath" (Mark 2:23-28).

The Pharisees asked Jesus why His disciples were doing what was unlawful on the Sabbath. Jesus answered them with the story of David when he was running from Saul. David and his men went to the house of God, to Abiathar the priest. They were hungry, and the priest said they had no food except for the showbread, which was only lawful for the priest to eat. David insisted that Abiathar feed him and his men. Abiathar asked him three questions: Are you sanctified, meaning have you been drunk? Have you had any riotous parties? Have you been with any women? David answered no to all three questions.

The priest pronounced him sanctified and fed him and his men the showbread. By eating the showbread, David was breaking the Law. However, he was not judged for it. Even though David was

fleeing from King Saul, his purpose was to become king. He was walking in his purpose until it manifested.

He went to the priest because it was the place of safety. When David arrived, all the priests had to eat was the showbread, or purpose, that was on the altar continually before the Lord. David did what was unlawful and still walked in his purpose.

What David understood and what Jesus was trying to get everyone to understand is that when you're walking in your purpose you can and will supersede natural laws and religious laws without being penalized.

Jesus was all God and all man. He knew the laws because He had written them. He would never have allowed His disciples to pluck and eat the ears of corn if it would have defiled or disqualified them from their purpose.

The Pharisees were trying to find fault with Jesus, but Jesus was consuming His purpose, so all natural laws and religious laws had to get out of His way. When you consume your purpose daily, natural and religious laws will get out of your way.

This is not a license to sin. That would be an immature way of thinking. D.I.V.A., I'm trying to help you grow up so that you can walk out your destiny. The Old Testament says, "The people that do know their God shall be strong, and do exploits" (Dan. 11:32). If you're trying to simply get by with excuses for sin, you'll never walk in your destiny.

God told me that Love Ministries Family Church would start in my home. I wasn't even in the house at that time. It was still on the market. But I would have to be in it in order to start the church on January 5, 1997. There was some damage to the house, so it was being sold "as is." The owners had said emphatically to every one who had bid on the house that they would not allow anybody to move into the house until the work was done, and whoever was bidding on the house had to pay for the work.

I said, "In other words, you expect me to put this much money into a house that I'm not living in?" After I fixed up the house, they could nullify my contract and raise the price of the house because I would have fixed everything that was wrong with it.

God said, "You will lease the house, live in the house, complete the work, start the church in the house, and then close on the house when the work is complete." Their CPA, their attorney, and everyone else said, "It is impossible. No one is allowed to live in the house." I would have to do the work on the house without living there.

My lease was up on the house I had been living in, and I didn't have anywhere to go. I had to put everything I had in storage and move my children in with friends. The day I was supposed to move into the house, I had a moving truck with all my things go to the house. It stayed there until five o'clock that afternoon, then left and came back the next morning. The people were still refusing to give me the keys to the house. At that time, we put everything back in storage. We had rented so many storage bins, we couldn't rent any more. I began selling what I could. I had two freezers full of food. I began giving it away because it began thawing out.

I prayed, "God, I believe I heard from you. You've got to move. I'm in the middle of my purpose. You said when I'm in the middle of my purpose that Heaven and earth will get in line to cooperate with me. God, I'm just trusting You, but I've got to see something."

It was the Wednesday before Thanksgiving. When I got up that morning, the Lord said, "Today is the day you're going to move into the house." The CPA called me about 1:30 that afternoon and said, "I can't figure out why, but the people have wired me from Switzerland. You may move into the house and have the work done. I'm going to have to draw up the papers, and I'll have all the papers for you by next week." I said, "No, you won't! You'll have those papers drawn up today. Even if I have to sign something temporary, I need the keys today." At 4:30 that afternoon,

the CPA drove from another city to meet me at the house to give me the keys.

We spent the holidays in the house, and the church started right on time. Everything had to get out of my way because I was walking in my purpose.

Fear knocked on the door, and purpose answered. I was daily consuming my purpose, so everything had to line up with me.

Since I'm here to equip you with the tools that will take you to the next level, I have one more point that will drive home the importance of you consuming your purpose daily. So pay close attention.

Priest of Purpose

I've shown you in the Old Testament where it was only lawful for the priest to eat the showbread. The priest ministered to God on behalf of the people. So they were actually praying on behalf of the entire nation before God daily. That was their job, their responsibility.

Let me ask you, whose responsibility is it to pray for your purpose daily? That responsibility still belongs to the priest. And the New Testament clearly tells us who the new priests are.

> But ye are a chosen generation, a royal priesthood, an holy nation, a peculiar people; that ye should shew forth the praises of Him who hath called you out of darkness into His marvellous light (1 Peter 2:9).

The daily consumption of your purpose is totally up to you. There is no longer a temple in Jerusalem, with priests dressed in ceremonial garments ministering to God daily. In this Scripture, you see that now you are the royal priesthood. It's your responsibility to pray over and consume your purpose daily. The Word says, "Give us this day our daily bread." We've been taught that this Scripture was only for provision. But how can God provide for you until you begin to walk in your purpose?

Your purpose is being revealed new to you every morning. Like the priest in the Old Testament, you are to eat your purpose daily. God reveals something new for you to pray over or consume every morning. You can't hold on to it for tomorrow because it has to be consumed that day.

God has to see your purpose before Him every day, and circumstances that look as though they are going to stop your progress will just get out of your way. Remember, this is not a "license to sin."

What are you supposed to be doing in the earthly realm? What is standing in the way of you seeing your purpose manifest? It doesn't matter; it has to move. As long as you're in the purpose of God that He has ordained for you, all of creation, not some of creation, has to cooperate with you to bring God's purpose to pass. He's the Creator, and everything He has lines up with everything He wants. You need to understand it's not over until you win.

Always remember when you are moving in your purpose, moving in your complete destiny, moving in the thing that God has for you; natural laws and religious laws bow to you, you don't bow to them.

CHAPTER 3

Focus on the Present...Learn From the Past

D.I.V.A., ONCE YOU'VE REMEMBERED YOUR purpose and gotten alone with God to receive instructions, next you'll need to learn how to stay focused on His purpose for your life.

> *Now sin is the sting of death, and sin exercises its power [upon the soul] through [the abuse of] the Law. But thanks be to God, who gives us the victory [making us conquerors] through our Lord Jesus Christ. Therefore, my beloved brethren, be firm (steadfast), immovable, always abounding in the work of the Lord [always being superior, excelling, doing more than enough in the service of the Lord], knowing and being continually aware that your labor in the Lord is not futile [it is never wasted or to no purpose]* (1 Corinthians 15:56-58 AMP).

From this very familiar passage I want you to focus on these words: "Therefore, my beloved brethren, be firm (steadfast), immovable, always abounding in the work of the Lord." Now, you're

going to learn how to stay firm, steadfast, and immovable so that you can abound in the work or purpose God has for you.

I want every D.I.V.A. to be aware that the work God has begun in you He is going to complete. What God has promised you He is able to perform. The Word of God is always working on your behalf even when circumstances make it look as though it's not. However, there are things that come to take your focus off what God is doing in your life, off your purpose. We're going to gird ourselves up, receive understanding, and successfully fight off the enemy of distractions.

Things to Overcome to Stay Focused

There are always things that will try to pull your focus off what you should be doing. There are three areas in particular that every D.I.V.A. will have to overcome in order to stay focused and abound in what you're called to do.

1. Dealing with self-correction.

2. Avoiding sin.

3. Staying focused.

The first thing that most of us find extremely difficult is dealing with self-correction. It may unfold like this: You begin pressing into God by setting aside time to spend with Him alone. You may want to develop a deeper walk, you need an answer to a specific situation, or you want to receive more insight concerning your purpose. No matter what the reason, there will always be things that come up that you weren't expecting.

These things usually have to do with you personally, with areas in your life that you need to correct. God begins to point them out so that you can take care of them. But there is something in us that won't allow us to get honest with God, deal with the situation, and move on. Something inside of us fights every attempt that we make to get that thing taken care of. That thing is called condemnation.

There is therefore now no condemnation to them which are in Christ Jesus, who walk not after the flesh, but after the Spirit (Romans 8:1).

The Word clearly says there is no condemnation for us in Christ Jesus. But we are so programmed for condemnation that we run every time God begins to deal with us personally. We would rather a prophet come up to us and condemn us, exposing the things going on in our lives publicly. But God's not like that. Remember, it's the goodness of God that leads to repentance.

God is not telling you publicly all the stuff that you're doing wrong, but as you mature, He is telling you privately. If I started pointing out your faults, you would want to correct them to prove something to me. However, it takes a mature D.I.V.A. to correct them because *God* pointed them out. It's a mature D.I.V.A. that will let God correct her and get that situation straight. It's a mature D.I.V.A. who will allow God to correct her and will not allow herself to fall under condemnation.

The second-hardest thing for every D.I.V.A. to overcome is sin. You need to get the understanding up front that sin is always going to be with you. Sin is always present with good. We've already established that sin is out there, but that does not give you a license to go out and participate in it. When you get to the point where you can allow God to correct you and not fall under condemnation, you will begin to build up a resistance to sin. It won't have the same power over your life.

We strengthen sin's hold over us when we begin to make excuses for it, fear it, or sweep it under the rug. It doesn't matter whether it's been running through your family line or not, either the blood works or it doesn't. It's time for you to take a stand and put this thing under the blood and move on. You ask, "Could it be that simple?" The answer is yes!

Once you've gotten past the first two points, it's time to move on to the third. It's now time to get and stay focused on what God

has called you to do. This is truly one of the most difficult things for us to do. There are so many things to come against you, against your mind, that it is easy to lose focus.

Think about how many people you know who get focused on what God has told them for a few weeks, a few months, or even for a few years: How long do they maintain their focus? They once knew what God said to them, yet ten years later, they aren't walking out their destiny.

The Lord showed me that I have some prayer requests that I began believing Him for in 1976 that have not come to pass. I haven't given up on them, nor am I sitting around growing bitter blaming God because those prayers have not come to pass. I also have some prayer requests from last week that have come to pass. Either way, I'm not getting offended and jumping ship. I'm staying focused on what I'm supposed to do. You've got to get to the point where you refuse to move from where you know you should be.

How to Stay Focused

Staying focused means to abide under, and to abide in, the appointed place with patience. You may be in a place where it seems that you are being productive, but doesn't mean that you're in the place that God has appointed for you.

However, there is a place of productivity where you can walk in the plan that God has for your life. How do you get there and stay single-minded and unchangeable toward the things of God and His instructions to you? One way is to plant the Word of God in your heart.

> *This book of the law shall not depart out of thy mouth; but thou shalt meditate therein day and night, that thou mayest observe to do according to all that is written therein: for then thou shalt make thy way prosperous, and then thou shalt have good success* (Joshua 1:8).

God instructed Joshua to meditate on His Word day and night so that he'd be successful. It worked for Joshua, and it will work for you also.

Have you ever received a prophetic Word? Did you write that Word down and pray over it and go into battle in the spiritual realm through prayer and seeking God to bring it to pass? Some people receive Word after Word and never take them home and never write them down with the date. They never go into their prayer closet and see exactly what God was saying to them.

When you receive a Word, you don't half-know what God is saying to you; you're just so excited that God is speaking to you, your mind "freaks out." The process stops right there for most people. You don't allow God to speak to you further about the Word, and it just dissipates. In order for you to stay focused and be unchangeable, you have to take God's Words and place them in your heart so that He can illuminate them for you. Then when things come against what God has said, you can take a stand and say, "Oh, no, that's not what God said to me." Then you won't be moved.

How many times have you been reading the Word of God and a certain Scripture jumps off the page at you? Did you highlight that Scripture and write the date next to it? Do you go back to that Scripture when you get into trouble and put God in remembrance of what He promised you?

When I'm in distress, sometimes I don't know what Scripture to look up I just open my Bible and flip through to the ones with the dates by them. I read them out loud, allowing the Word of God to minister to me again. There are some Scriptures that have several dates by them. This represents all the different times those Words became alive to me.

He's God and He changes not! You don't have to look for a new Word; just tap into what God has already said to you.

Original Instructions

When I try to get off track about what I'm supposed to do or when I don't know what to do, I turn to my original instructions.

> *The Spirit of the Lord God is upon me; because the Lord hath anointed me to preach good tidings unto the meek; he hath sent me to bind up the brokenhearted, to proclaim liberty to the captives, and the opening of the prison to them that are bound; to proclaim the acceptable year of the Lord, and the day of vengeance of our God; to comfort all that mourn...* (Isaiah 61:1-2).

This is the Scripture that God used to call me into the ministry. So no matter where I am, where my ministry is, or what I'm doing, I always go back to my original instructions.

It doesn't matter what title I wear: apostle, prophet, pastor, evangelist, or teacher, God's original instructions to me were, "The Spirit of the Lord has come upon you, Terri Little, because I have anointed you to bring good tidings to the meek. I have sent you to bind up the brokenhearted. I want you to proclaim liberty to the captives. You will open the prison to them that are bound, and you will proclaim the acceptable year of the Lord. And you will comfort them that mourn." Those were my original instructions, and I've never deviated from them.

When you understand your original assignment, you won't become distracted. You can always go back to your original instructions, and you'll never lose focus.

Identifying Distractions

When distractions come against us, they seem to come from out of nowhere. They also seem to take on a life of their own. However, the truth is there are only three areas of distractions that you must identify and deal with in order to maintain focus: satanic distractions, natural distractions, and self-made distractions.

Let's begin with the most obvious of the three, satanic distractions. These are distractions that are being sent to you to interrupt your productivity in the things of God. They aren't just simple distractions, they are being strategically sent to negate your productivity in the spiritual realm, stopping you from fulfilling your assignment.

Satanic distractions can be something as simple as a nagging headache that only occurs right at the moment you begin to pray. Or, it could be as severe as your child coming under attack during your time of testing, when you're in line for a spiritual promotion.

You know there is no mother on earth that can stay focused when her child is under attack. Even so, you'll still need to deal with the source of the attack so that your child isn't lost and neither is your promotion. Either way, God is still in control and can teach you how to stay close to Him so that nothing is lost and you gain the victory.

Next, there are natural distractions, and these are things that happen to us in our day-to-day living. There really isn't a whole lot we can say about them. They're just simple little irritants that come our way. It's how we handle them that will determine our placement in Kingdom business. If you fall apart every time you burn the toast or every time you stub your toe or wake up late or a friend calls at the last minute to ask for a favor, you won't get very far. I suggest you build yourself up in the Holy Ghost so that these little things don't get you off track.

The last area is self-made distractions, and they are always due to bad choices. For instance, you were going to wake up early to have your quiet time with God, but you sat up late the night before, and you just couldn't wake up the next morning. In the afternoon you sit down to pray, and the phone rings. You debate whether to answer it, but you give in and spend the next three hours on the phone talking about nothing. You've missed your time alone with God again.

Then there are the kids. Instead of putting the little ones to bed early and telling the older ones you want some quiet time, everyone sits up to watch the late movie. Then after the movie, you want to snuggle with your husband because it's important for the two of you to spend time together. The entire day is gone, and you haven't spent any time alone with God. The bottom line is you simply need to prioritize your time and learn the importance of saying no even to yourself.

Have you ever noticed that those same distractions never stop you from going to work? I want you to see this: everything is going on in your life, you're getting it from all sides, but you still get up and go to work.

But for the time that God has set apart that He wants to minister to you, everything comes against you and pulls you away from receiving from God. That stops your productivity in the spiritual realm, and it's up to you to cut it off.

God's Five-Fold Covenant

In order for you to fight responsibly in these three areas, you must recognize that you have a five-fold covenant with God that covers everything that you will ever encounter. When distractions hit you in the satanic, natural, and self-made arenas, always remember that they are going to hit you in one of these five realms: the spiritual realm, the physical realm, the financial realm, the mental realm, and the social realm. This is because this is your five-fold covenant of blessings. Every promise that God has made to His children fall under one of these areas. So, if God has made you promises in all these areas, the enemy is going to try to strike here. However, you have this five-fold covenant of prosperity with God that ensures you victory in these areas.

If you find that you're lacking in one of the areas of your five-fold covenant, it's your responsibility to get before God and allow Him to show you which of the three areas of distractions have been

allowed to operate in your life. Then with the Word of God, you go into battle in the spiritual realm through prayer and fasting to secure your victory.

For instance, one area of your five-fold covenant of prosperity is the financial realm. Now, let's say that in the area of finances you continue to come up short. To you this is incomprehensible because you're a tither and you give over and above, but you can never seem to make ends meet. Not only that, you also seem to be falling further and further behind. Then, when you get sick and tired of being sick and tired and you're ready to do something about your situation, you go to God for help.

This is a clear-cut, no-holds-barred distraction. But which of the three areas has brought this about? Is this a satanic attack or a natural or self-made distraction that's going on?

Whatever the case may be, God has your answer, and it's up to you to get alone with God to get the answer and the strategy that will help you overcome the distraction so you can get back to the area you really should be focused on, which is your purpose.

You need to identify where the distractions are coming from. If it is natural or satanic, we already have the victory because we have the Word of God. We've been given dominion over the enemy of our soul and over natural elements. So this shouldn't be a problem for you. You simply rise up take the sword of the Spirit (which is the Word of God) and the authority that you've been given and claim your victory.

However, self-made distractions are a completely different thing and cause you to face the judgment of God. That may sound harsh, but it is true. You must understand that judgment in the house of God is never for destruction; judgment in the house of God is always for deliverance. God is judging you to deliver you from making the same mistakes over and over again. Every time you have to repeat something in your life because of self-made distractions, you hold yourself back. Then you're left believing that

God doesn't want to bring His Word to pass in your life. Maybe you believe that things will never happen for you and that victory is just for other people. That's a lie of the enemy. Victory is also for *you*!

We must be disciplined enough, even when we're confused and hurting so badly we don't think we can go on, to get into the Word of God and receive our answer. Sometimes, even with all the Scriptures I know, I can't think of the right one. I just look through my Bible, and I get one of the old ones with a date by it and read it to myself. The Word of God will never return void. It will always prosper whereunto it is sent. As I'm reading, I remind God with each Scripture that He said the victory was mine.

Staying focused also means that you will never be confused. You may not know when, why, or how, but you will know what God has said to you. When you know what God is saying, you will never be confused. Sometimes the things in your life all seem to be coming at you all at the same time, falling like dominoes, one thing right behind the other. You get a new job and a new responsibility, then God is telling you to do something all together different.

All of this hits you at the same time. Have you ever been there? You may not know how to do it. You may not know why you should do it. You may not know when it's all going to come together for you, but you do know what God has said to you. That's a good place to begin to build a point that you can focus on.

The "what" will always begin with God's original instructions to you. That's why I told you I can always go back to Isaiah 61, my original instructions. That's why I asked you about the prophecies you've been given and the Scriptures that God has illuminated for you in His Word. Have you heard exactly what God was saying to you? Have you gotten alone with God and allowed Him to take that thing apart and show you word by word what He was saying?

Have you gotten on your face and said, "God, I heard what the man of God was saying, but what are You saying? I heard the words they used, but what were You saying to me?" The "what"

starts with God's original instruction to you. Go back to His original instructions!

Any secondary instructions that you receive from God will never negate the original instructions that you've been given. When God called me to the prophetic realm, when He called me to pastor, when He called me to set up churches around the country, when He told me that I would start a school for prophets, not one of these instructions conflicted with "The Spirit of the Lord God is upon me; because the Lord hath anointed me to…."

When anything in your life comes to distract you from the original instructions, now you know how to fight. You don't have to call up Brother and Sister So-and-So to speak a Word into your life. All you have to do is open your mouth and put yourself in remembrance of what God promised you. You'll have victory because you'll keep God's original instructions in front of you.

When you don't know that you have a covenant with God, then any distraction can easily get you off course. But you're going to stay firm, steadfast, immovable, always abounding in the work of the Lord, doing away with all distractions. And never forget your original instructions.

IMPARTATION III

Virtuous

Virtuous

When you hear the word "virtue," what does it bring to mind? When you hear the term "virtuous woman," what does that bring to mind? If you're having a problem with this, allow me to shed some light on the subject of a virtuous woman. Often, we think of a pious, overly religious woman in a black dress with a collar up to her chin, no make-up, hair pulled back in a bun, always carrying a Bible, and able to quote Scriptures at the drop of a hat. More than likely, she's the one dropping the hat. However, that's not biblical virtue. In fact the Bible gives us a completely different picture of a virtuous woman.

Proverbs 31, a very familiar passage of Scripture, describes a virtuous woman. It starts out by asking the question, "Who can find a virtuous woman?" Then it lets us know her worth: "for her price is far above rubies." The intensity of what this passage of Scripture describes changes our viewpoint on virtue and virtuous women.

We don't see what is described in Proverbs 31 as the "norm" for the women in the Body of Christ. What we see is jealousy running rampant through the Church. We see control, manipulation, back-biting, and hatred, just to name a few. That's not a putdown, but what I'd like for it to be is a wake-up call. You can't live your lives in deception any longer.

I believe one reason we don't see biblical virtue is because whenever this Scripture has been taught, women are often left with the impression that they are to be superwomen. Think about it: This woman does it all. She wears many hats. She's a wife and mother, her house is always in order, she runs her own business, she buys fields and farms the land. She makes her own clothes, and the list goes on.

Let's get real. There is no way that any one woman can do all these things. First of all, there's not enough time in a day. Proverbs 31 isn't talking about one woman. This is a compilation of different women. Some women aren't interested in owning their own business. These days, most women can't make their own clothes. Most have moved from the farm to industry, and now to technology. There are not that many women left planting and harvesting fields.

What you should be getting from this Scripture is that no matter what God has purposed for you to do in this life, as long as you keep Him first, you will never fall short. You begin by recognizing that order is the rule of the day.

A virtuous woman is one who is in order and handling her business, which is God's business. She's not out and about playing mind games trying to control other people. Her family and her home are tended to. Within the heart of a virtuous woman beats order. She serves a God of order. Regardless of whether she's reaching out to God or God is reaching out to her, their relationship is encapsulated in order. We are going to learn to walk in order so we can walk in God's power and protection to fulfill our destiny.

CHAPTER I

Clear the Clutter

D.I.V.A., WHAT HAPPENS WHEN YOU INQUIRE of the Lord and He answers you? God, the Creator of the universe, has made you a promise. When it's not happening in your time or the way that you think it should, you try and figure out how you're going to make it happen for yourself. Without realizing it, you have just introduced disorder into your life, and I've heard this all of my life: "God don't bless mess."

God made Abraham a promise, and somewhere along the way, Abraham and his wife Sarah decided to change God's plans around. But as you'll see that didn't matter to God because it's always God's way or the highway.

> *After these things the word of the Lord came unto Abram in a vision, saying, "Fear not, Abram: I am thy shield, and thy exceeding great reward." And Abram said, "Lord God, what wilt Thou give me, seeing I go childless, and the steward of my house is this Eliezer of Damascus?" And Abram said, "Behold,*

to me Thou hast given no seed: and, lo, one born in my house is mine heir." And, behold, the word of the Lord came unto him, saying, "This shall not be thine heir; but he that shall come forth out of thine own bowels shall be thine heir." And He brought him forth abroad, and said, "Look now toward Heaven, and tell the stars, if thou be able to number them": and He said unto him, "So shall thy seed be" (Genesis 15:1-5).

God promised Abraham not only a child but that his lineage would be more numerous than the stars in the sky. So, needless to say, Abraham was a little concerned that he hadn't seen this promise come to pass. There was no heir for his fortune. However, God promised, and Abraham believed Him. Before the child of promise was conceived by Sarah, which was God's perfect order, disorder was introduced into their family line.

Now Sarai Abram's wife bare him no children: and she had an handmaid, an Egyptian, whose name was Hagar. And Sarai said unto Abram, "Behold now, the Lord hath restrained me from bearing: I pray thee, go in unto my maid; it may be that I may obtain children by her." And Abram hearkened to the voice of Sarai. And Sarai Abram's wife took Hagar her maid the Egyptian, after Abram had dwelt ten years in the land of Canaan, and gave her to her husband Abram to be his wife. And he went in unto Hagar, and she conceived: and when she saw that she had conceived, her mistress was despised in her eyes. And Sarai said unto Abram, "My wrong be upon thee: I have given my maid into thy bosom; and when she saw that she had conceived, I was despised in her eyes: the Lord judge between me and thee."…And Hagar bare Abram a son: and Abram called his son's name, which Hagar bare, Ishmael (Genesis 16:1-5;15).

Abraham desired a son. However, by going into Hagar, he introduces disorder into his household. Hagar and Ishmael were not God's will for Abraham's life.

Now is a good time for you to stop and ask yourself what have you introduced into your life that isn't God's will? This is the time to begin to get some things straight with God. Oftentimes, something looks like a good idea, but it isn't a God-idea, and we end up in chaos, and we really don't know why. Let's see what happened to Abraham.

Sarah decided that God had shut up her womb and that she would give her maid to her husband. She would obtain children that way. Abraham agreed, but it wasn't because he did not believe God. You would have to have a tremendous amount of faith to believe that an old man could produce anything, let alone producing it with a young woman like Hagar.

So Abraham never staggered at the promise of God. But he saw that Sarah couldn't believe. So when Sarah offered him Hagar, through sheer determination he said, "A baby is coming one way or the other, and I'm going to be the father."

However, that was not God's perfect order for the father of faith. This one act brought dissension into their midst. Sarah said, "The Lord judge between me and thee." God did not destroy Abraham for producing Ishmael, but Ishmael wasn't the rightful heir.

Then there came a time when Sarah was able to believe the Word of God. God was able to produce the heir to Abraham's fortune through her. This was God's perfect order for their lives.

> *And the Lord visited Sarah as He had said, and the Lord did unto Sarah as He had spoken. For Sarah conceived, and bare Abraham a son in his old age, at the set time of which God had spoken to him. And Abraham called the name of his son that was born unto him, whom Sarah bare to him, Isaac* (Genesis 21:1-3).

Abraham desired a son. That was a good and godly desire, but only order could produce an heir and their destiny. Both Abraham

and Sarah had to be in agreement for the promise to come to pass. That promise was Isaac.

By the time the promised arrived, there was still dissension in their midst, and Ishmael had to go. The seed of disorder could not remain in the same place where the order of God was to be nurtured so it could grow and flourish, eventually producing their destiny. So again, Sarah took action.

> *Wherefore she said unto Abraham, "Cast out this bondwoman and her son: for the son of this bondwoman shall not be heir with my son, even with Isaac." And the thing was very grievous in Abraham's sight because of his son. And God said unto Abraham, "Let it not be grievous in thy sight because of the lad, and because of thy bondwoman; in all that Sarah hath said unto thee, hearken unto her voice; for in Isaac shall thy seed be called"* (Genesis 21:10-12).

This was no light thing for Abraham. He loved Ishmael, but the entire situation was out of God's perfect order for their family and destiny. It had to be made right for them to walk in the place of power that God had ordained for them.

A similar thing happened in the life of Isaac with his wife Rebekah. However, he took a different approach to solving his problems. When Isaac found out that his wife was barren, the Word says he entreated God.

> *And Isaac intreated the Lord for his wife, because she was barren: and the Lord was intreated of him, and Rebekah his wife conceived* (Genesis 25:21).

This is the perfect picture of order. Isaac realized there was a problem. He went to God in prayer. God opened Rebekah's womb. Instead of going through years of drama, Isaac went straight to God and received an answer. Rebekah gave birth to twins, Esau and Jacob. Isaac desired a child. He walked in the order of God and received his destiny.

This may seem like a very simple example, but how often has God spoken a promise to our hearts and we've decided that we know best? How many times have we changed things around trying to help God out? When exactly did God express that He needed our help for anything?

D.I.V.A., this is the perfect example of what happens when we take our eyes off God.

CHAPTER 2

When the Student Is Ready, the Teacher Shows Up

So now that you are beginning to get things in order, we've got to learn how to make our desires line up with God's destiny for our lives.

See, it was Abraham's desire to have a son; there's nothing wrong with that, but the destiny of the entire human race depended on both Abraham and Sarah getting it right. Eventually they did. So did Isaac. Right from the beginning, he did what he should. Isaac's desire produced his destiny. This is the example we should follow.

Then there's Jacob, Abraham's grandson. He's called the trickster. Jacob was determined to get what he desired by any means possible. In Jacob's eyes it didn't matter that his desires didn't line up with his destiny; he was determined to do things his way.

Jacob and his twin brother, Esau, grew up knowing the promise that God had made to their grandfather. It wasn't a secret. It was something for the entire family to be proud of and

strive toward. However, Esau, who would inherit the promise, didn't see it that way.

> *And Jacob sod pottage: and Esau came from the field, and he was faint: and Esau said to Jacob, "Feed me, I pray thee, with that same red pottage; for I am faint": therefore was his name called Edom. And Jacob said, "Sell me this day thy birthright." And Esau said, "Behold, I am at the point to die: and what profit shall this birthright do to me?" And Jacob said, "Swear to me this day"; and he sware unto him: and he sold his birthright unto Jacob. Then Jacob gave Esau bread and pottage of lentiles; and he did eat and drink, and rose up, and went his way: thus Esau despised his birthright* (Genesis 25:29-34).

Esau was in line to be a part of the destiny of the family of faith. His desire was to satisfy his flesh. He sold his birthright for a bowl of stew. Then, in Genesis chapter 27, it tells the entire story of how Jacob, after plotting with his mother, deceives his father and receives his brother's blessing. Esau vowed to kill Jacob, which led Rebekah to send Jacob away to her brother.

We all too often hear about generational curses, but we don't always hear about generational blessings. Jacob was blessed because he was in the family line. No matter how disobedient he was, God had made his grandfather a promise. God was not going to allow anyone or anything, including Jacob himself, to mess that up. This is what's going on now in the Body of Christ.

God has made you some promises, or maybe there were some promises made to your ancestors. Some of those promises haven't come to pass and are still in your family line. God is pulling on them to produce in your life.

Have you been wondering why you haven't been able to do the same things you used to do? I'm not talking about sin. I am talking about things that are getting in the way of your destiny. We are in a new dispensation. God is saying to you that you may have lived under the family curse, but now it's time for you to walk in

the family blessing. In order for that to happen, you've got to get yourself in order.

Whatever you've been desiring may or may not have been all right in the past. If it gets in the way of you fulfilling your destiny, it's got to go! Somewhere along the way, you're going to meet up with someone who is not going to be willing to help you compromise order, or what God has promised you.

Then Jacob went on his journey, and came into the land of the people of the east....And while he yet spake with them, Rachel came with her father's sheep; for she kept them....And Jacob told Rachel that he was her father's brother, and that he was Rebekah's son: and she ran and told her father. And it came to pass, when Laban heard the tidings of Jacob his sister's son, that he ran to meet him, and embraced him, and kissed him, and brought him to his house. And he told Laban all these things. And Laban said to him, "Surely thou art my bone and my flesh." And he abode with him the space of a month. And Laban said unto Jacob, "Because thou art my brother, shouldest thou therefore serve me for nought? Tell me, what shall thy wages be?" And Laban had two daughters: the name of the elder was Leah, and the name of the younger was Rachel. Leah was tender eyed; but Rachel was beautiful and well favoured. And Jacob loved Rachel; and said, "I will serve thee seven years for Rachel thy younger daughter." And Laban said, "It is better that I give her to thee, than that I should give her to another man: abide with me." And Jacob served seven years for Rachel; and they seemed unto him but a few days, for the love he had to her. And Jacob said unto Laban, "Give me my wife, for my days are fulfilled, that I may go in unto her." And Laban gathered together all the men of the place, and made a feast. And it came to pass in the evening, that he took Leah his daughter, and brought her to him; and he went in unto her. And Laban gave unto his daughter Leah Zilpah his maid for an handmaid. And it came to pass, that in the morning, behold, it was Leah: and he said to Laban,

"What is this thou hast done unto me? Did not I serve with thee for Rachel? Wherefore then hast thou beguiled me?" And Laban said, "It must not be so done in our country, to give the younger before the firstborn. Fulfil her week, and we will give thee this also for the service which thou shalt serve with me yet seven other years." And Jacob did so, and fulfilled her week: and he gave him Rachel his daughter to wife also. And Laban gave to Rachel his daughter Bilhah his handmaid to be her maid. And he went in also unto Rachel, and he loved also Rachel more than Leah, and served with him yet seven other years (Genesis 29:1;9;12-30).

Jacob, the trickster, is ready to move into his place of blessing, but not like he should. Have you ever noticed every time you hear about this family line you hear "Abraham, Isaac, and Jacob"—not "Israel" but "Jacob." There is a specific reason for that. God changed Abram's name to Abraham before he received his promise. Then God told Abraham to name his son Isaac. In the Bible, names mean something. They speak to who you are to become. Jacob means "trickster," and God didn't change his name right away. That's because Jacob wasn't ready or willing to change. Jacob represents where you are right now. God is waiting for you to get cleaned up on the inside. He's waiting for more deliverance to come. He's waiting for you to get your desires in order so that He can begin to speak to where He wants to take you.

God is big enough to create in us and make us what we ought to be. That's encouraging to me because sometimes, when I evaluate where I am, I'm not always where I should be. This is not because I'm not trying to get there; I just miss it. I'm not talking about sin. This book isn't for someone in sin or searching for sin. Sometimes I feel like I'm not where I want to be. But God has us all on the right track so that at the appointed time, He can speak into our lives and change our name to Israel, so we can walk out our destiny.

Jacob's entire existence, up until this point, has been out of order. He was the second born, but through deception, he received

the birthright and blessing of the oldest child. This placed him in line for the promise that God had made to his grandfather. But in order to fulfill it, he needs a wife.

Like Abraham, the father of faith, his son Isaac, and now Jacob, we all have desires. We run into trouble when we allow those desires to have control over us. They can pull us out of the will of God for our lives, leaving us powerless to walk out our destiny. In this chapter, we'll look at how God deals with the desires you have inside and put you in order so that you can fulfill your destiny!

Let's take a look at Jacob's life. Let's examine where he began, where he went, and how he got there. Jacob had been with Laban for a month. Laban went to him and said, "Work for me and you can pick your wages." Jacob asked Laban for Rachel, his youngest daughter. This was totally out of order, and Jacob knew it. Jacob was slick. He was a smooth talker. He was one of those fellows who could talk to you and sway you and get you to see and agree with his point of view. But now, Jacob the trickster had been tricked.

He worked seven years then went to his uncle and asked for his wife. The night of the wedding, the bride went into her husband with a veil over her face. When Jacob woke up the next morning, the veil came off, and he ran out of their bedchamber screaming in horror. He realized that the woman he had just married wasn't Rachel, the love of his life, the woman he desired, the woman that made seven years of work seem like only a few days. It was Leah. He had married the wrong woman. But wrong in whose eyes?

Leah had lived all of her life in the shadow of her beautiful, well-favored younger sister. "Leah was tender eyed; but Rachel was beautiful and well favoured." Not only was Leah not attractive, some theologians say that the reference "tender eyed" meant that Leah was cross-eyed. On top of this, she found out that her husband really wanted her younger sister, not her. Now she could add rejection to the list.

This same situation may not be happening to you today. However, rejection is running rampant through our personal lives and through the Church. Have you ever thought that you were hired for a job because they thought you were the best? Then you find out that they settled for you because they couldn't get the person that they really wanted. So now you're working with a team of people, but you're really not a part of the team because the rest of the members won't include you in anything. Even though you're there, you've never really been accepted. Now rejection begins to build up on the inside of you.

It doesn't have to be work related. It could be in any area of your life where you feel rejected. There seems to be nothing you can do about it. Just hang in there. You'll see how even though they rejected you, God never has. You can still walk in your destiny.

After spending the entire night with Leah, Jacob rejected her. Leah went into her husband, as a virgin, believing that this was what he wanted. She wasn't a part of the deception. The original conversation was between Jacob and Laban. In her mind, she was going in to her husband. Then, after she has been there all night long, the next morning her husband discovers he hasn't gotten what he desired and worked for seven years to get.

Have you ever wondered how it was possible for a man to love a woman the way Jacob loved Rachel, then spend all night with a woman and not realize until morning that it wasn't the woman he loved?

Could it be that Jacob indeed desired Rachel but never really took the time to get to know her? I wonder how many women in the Body of Christ today are sleeping with their husbands and don't know them? Jacob may have desired Rachel, but he didn't know her. He didn't know her heart. He didn't know her soul. He didn't know her.

So now, Jacob was out and about, ranting and raving like a crazy person because his uncle had tricked him. When he asked Laban

why he did this to him, his uncle responded with something that Jacob hadn't been willing to face—the truth.

> *And it came to pass, that in the morning, behold, it was Leah: and he said to Laban, "What is this thou hast done unto me? Did not I serve with thee for Rachel? Wherefore then hast thou beguiled me?" And Laban said, "It must not be so done in our country, to give the younger before the firstborn"* (Genesis 29:25-26).

What Laban was actually saying to him was, "Yeah, I know you're Abraham's grandson. I know you're the seed of promise, but if you don't get your life in order, the promise is going to pass you by." It's simple when you look at it. Jacob knew the customs and laws of these people because they were his people. They were his family: his mother, father, and grandparents came from this place. The law was that the oldest daughter was to marry first. But Jacob desired the pretty, fine, young daughter, not the unattractive, crossed-eyed sister. Since he had gotten by with his slick ways before, he figured it would work for him now. This time it was different. It was time for the promise of God to be fulfilled, but he wasn't ready. He hadn't sanctified his flesh enough to receive it. He knew how to work the Word, but he wasn't submitted to the Word.

Laban understood the promise that God had made to Jacob and his family. He also understood that if Jacob didn't get in order, the promise would not come to pass. God will not bless disorder.

Maybe you are right now going through difficulties: financial, emotional, health challenges. Things are going on in every area of your life. It's because everybody that God is going to use is going through something to bring him or her to a place of order. God is bringing you into the place that He has ordained for you.

God will take you the easiest way that you will go. Because Jacob wasn't willing to get right with God, he was sent to a trickster from the old school who saw promise and destiny in him and

refused to allow him to get by with disorder any longer. Laban was saying, "Because you are a part of my family and I love you, I can't let you think you're going to get it without going through proper protocol. I can't let you think that you're going to get it without order, that you're going to walk in something and be a success without going through the rules and the hard knocks that everybody else has had to go through."

Laban understood that their entire family and the families of the whole world were tied up in Jacob. Somebody was going to have to bring this boy into order.

Can the same be said about you?

I could say, "I know you're Miss Faith from a long line of great faithful people. I know you know how to name it and claim it. I know you know how to quote Scriptures and make them work for you and get everything you want. But if you're going to fulfill your purpose and destiny, you're going to have to get in order. Now maybe you can break the law where you come from, but in the twenty-first century we're going to do it God's way or no way at all."

I can teach this because I teach quoting and I believe the Word of God shall not return void. I'm not going to stop quoting. But I also believe I have to have some substance in my life. I have to be submitted to God's Word. I'm not just using the Word of God to manipulate my situation around to serve me. When I don't understand the true meaning of what God is saying in a situation, I need to wait on God. I need to hear what God is really saying to me. Then I can take His Words and apply them to my situation.

Laban takes a righteous stand in the face of someone who was used to being deceptive and getting whatever he wanted. He tells Jacob that the law says the eldest daughter has to be married first and that he could work another seven years for Rachel. Jacob loves Rachel so much, he agrees. Desire is costing him another seven years when order and purpose is already sitting right under his nose in the form of Leah.

And when the Lord saw that Leah was hated, he opened her womb: but Rachel was barren (Genesis 29:31).

Jacob finally gets the thing that he so deeply loved and desired. But sometime during those second seven years, he developed a deep hatred for Leah, the one he had been tricked into marrying. This word "hated" in the Hebrew means that he personally and utterly disliked her. You know how someone may say to you they don't like you, but don't take it personally? They may possibly not like something about your character. It's just one thing, so they tolerate you. Jacob did not like anything about Leah to the point that it was personal. He hated Leah.

Jacob wasn't used to being on the receiving end of deception, and he had no intention of getting into order. He enjoyed his life. He had gotten everything that he wanted up until that point; why should he even attempt to play by the rules now? Every time he looked at Leah, she represented everything that was forcing him to sanctify his flesh and get in order for his destiny. And everything within him fought against that.

People want to be used by God, but they don't want to go through protocol. They think being free and loose is independence; it's not. Freedom requires more submission than you know anything about. Being used by God means you no longer belong to yourself, you belong to God. And what He says goes. You have no agenda of your own. If you're going to succeed in the twenty-first century, you're going to have to get that mindset. You have to understand that you don't have a desire of your own. Jacob loved Rachel, the thing he desired, but Leah was his destiny.

God is putting the Church in order, but it begins with you personally. He's putting everything about you in order. He's putting your family in order, your business in order, your thoughts in order, and your money in order. How can God trust you with one thousand dollars when He can't trust you with ten? If you began your

week with one hundred dollars and by the end of the week you don't know what you did with it, how can He trust you with more?

If anyone says anything to you about your money, you're ready to defend what you did with it. I didn't say you did something wrong with the money, you just may not have done the highest thing with it. Stop being so programmed for condemnation. Just get in order and stop being so defensive. That's why you can't hear from God: you're too busy defending what you've already done. He can't even show you a new viewpoint. Either you're going to get in order and do it God's way, or you're going to spend seven more years working for your own desires.

Jacob worked seven years, and Laban tricked him into marrying Leah. He worked seven more years and married Rachel, his heart's desire. He agreed to work seven more years, tending Laban's flocks. His pay this time would be only spotted, speckled, and striped animals. While he was hard at work, God opened Leah's womb. She began producing the destiny that Jacob's family had longed for. The one he hated, the one he rejected, was now producing his destiny. The one he desired wasn't producing anything.

> *And Leah conceived, and bare a son, and she called his name Reuben: for she said, "Surely the Lord hath looked upon my affliction; now therefore my husband will love me." And she conceived again, and bare a son; and said, "Because the Lord hath heard I was hated, he hath therefore given me this son also": and she called his name Simeon. And she conceived again, and bare a son; and said, "Now this time will my husband be joined unto me, because I have born him three sons": therefore was his name called Levi. And she conceived again, and bare a son: and she said, "Now will I praise the Lord": therefore she called his name Judah; and left bearing* (Genesis 29:32-35).

With the birth of her first child, Reuben, Leah said, "Now therefore my husband will love me." Leah actually believed that Jacob would love her because she gave him his firstborn child. It

didn't happen. Have you ever felt rejected even after you accomplished something you felt would cause you to be accepted? Did you think that the people around you would see that you were just as good as they were, and they didn't? Maybe they didn't even care?

With the birth of her second child, Simeon, she said, "The Lord hath heard that I was hated." This is some serious hatred. Jacob didn't care whether Leah was aware that he hated her. Leah was aware of the hatred, but not the fact that God was on her side because she was in order. She had begun producing Jacob's destiny.

With the birth of her third son, Levi, she said, "Now this time my husband will be joined to me." Jacob has been sleeping with her all this time, and Leah knows he wasn't joined to her. She knows that he's sleeping with her, but he doesn't love her. He's in love with her younger sister. The one he hates is birthing his destiny; the one he desired hasn't produced anything yet. You've got to see that just being in order will produce your destiny.

With the birth of her fourth child, Judah, Leah said, "Now will I praise the Lord." I think Leah is finally waking up. Here is Leah giving birth to the destiny of this family. Her life is in order, and she's producing. But because she feels rejected she can't even see or appreciate the good work that she's doing. With that comes self-condemnation. She is giving this man his whole purpose and destiny, which could not have been fulfilled without her, and she doesn't even know it.

Finally, after four children, Leah is still not getting anywhere with Jacob, so she turns to God and gives Him her praise. On the other side of this equation, Rachel still hasn't conceived. Then something interesting transpires.

And when Rachel saw that she bare Jacob no children, Rachel envied her sister; and said unto Jacob, "Give me children, or else I die." And Jacob's anger was kindled against Rachel: and he said, "Am I in God's stead, who hath withheld from thee the fruit of the womb?" And she said, "Behold my maid Bilhah, go in unto

her; and she shall bear upon my knees, that I may also have chil-
dren by her." And she gave him Bilhah her handmaid to wife:
and Jacob went in unto her. And Bilhah conceived, and bare
Jacob a son. And Rachel said, "God hath judged me, and hath
also heard my voice, and hath given me a son": therefore called
she his name Dan. And Bilhah Rachel's maid conceived again,
and bare Jacob a second son. And Rachel said, "With great
wrestlings have I wrestled with my sister, and I have prevailed:
and she called his name Naphtali" (Genesis 30:1-8).

This part of the story begins with Jacob getting angry with
Rachel: the one he loved, the one he had worked fourteen years for,
and the one he deeply desired. He was angry with her because she
blamed him for her not having any children. But there is some-
thing interesting here. The Scripture says, "And when Rachel saw
that she bare Jacob no children, Rachel envied her sister." Rachel
envied what her sister had. The one that was desired and loved is
now envious because she looks at her sister and sees what she could
have, but doesn't.

Things such as envy, jealousy, manipulation, and control are
detrimental to the life of a believer. Once these things crop up, they
must be dealt with immediately. They cannot be allowed to take
root in your system. They are strategically sent by the enemy to
come against the purpose of God for your life.

This goes back to Jacob's grandfather, Abraham, when he lis-
tened to his wife, went in to her maid, and conceived a child. That
opened the door for envy and jealousy. Then with Isaac's children,
Esau and Jacob, Isaac favored Esau while Rebekah favored Jacob.
This was something traveling through the family line, something
that needed to be dealt with but hadn't been.

It even resulted in ten of Jacob's sons selling one into slavery,
then lying to their father that he had been killed. Jealousy and
strife will stifle your productivity in God and diminish your abil-
ity to live out your destiny.

Leah had given birth to four sons. Rachel was angry with Jacob because she was still barren. Then she came up with a wonderful idea: she would give Jacob her maid Bilhah, and she, Rachel, would have children through her. Does that sound familiar? Bilhah gave birth to two sons. Leah, or destiny, had produced four offspring, and desire had not produced anything yet.

However, after the birth of Bilhah's first child, Rachel said, "God hath judged me, and hath also heard my voice, and hath given me a son." It's amazing how you can pray and confess things, rearrange them, and make everything look the way that you want it to look. The truth is Rachel was still barren, but, because her maid had given birth, she believed God had judged her, heard her voice, and given her a son.

Bilhah conceived a second time, and Rachel said, "With great wrestlings have I wrestled with my sister, and I have prevailed." Now she thought she was competing with her sister Leah, and she had deceived herself into believing that she had prevailed over her.

We're just like that, circumventing God's plan, doing it out of order, believing the ends will justify the means. Everything is out of order, but just because something shows up, we believe that God has blessed our mess. Just because God chose to "bail you out" one more time, you think you've gotten away with something. Never once did you realize that was the mercy of God. But then you end up right back in the same mess again, and you still wonder why. That thing just keeps coming back bigger and stronger each time, and you still refuse to get alone with God and deal with it God's way.

Jacob had some issues in his life that he wasn't willing to deal with, issues that led to him working fourteen years for something he desired. Had he just been up-front with his uncle, he would have been able to work for both Leah and Rachel, cutting some of that time down. He didn't think Leah was attractive, and he didn't want her. He ended up with both of them anyway. If things didn't seem to be strange enough with this dysfunctional family, Leah

gave in to the dictates of envy, jealousy, and competition. Just like her sister, she gave Jacob her maid as a wife.

> *When Leah saw that she had left bearing, she took Zilpah her maid, and gave her Jacob to wife. And Zilpah Leah's maid bare Jacob a son. And Leah said, "A troop cometh": and she called his name Gad. And Zilpah Leah's maid bare Jacob a second son. And Leah said, "Happy am I, for the daughters will call me blessed": and she called his name Asher* (Genesis 30:9-13).

Things didn't change for Leah. She played into that same simple deception that had consumed Rachel. She gives her maid to Jacob because this rivalry with her sister has overtaken her. Somewhere in the back of her mind, she's trying to keep up with her sister, but she doesn't realize that because she was in order, she began at a different level than Rachel did.

I've already told you that your life can be in order and you can be producing destiny, but because you feel rejected, you can't even see or appreciate the good work that you are doing. It's as though you're living in a fog, and the only thing you can think of is to accomplish one more thing, and then someone will recognize or appreciate you. But you haven't recognized or appreciated yourself.

Leah was the first wife, so she really should have been the "queen bee," and all the others were concubines. They should have been the second-class citizens, but that wasn't the case. Leah was the one living like the downcast second-class citizen. Leah should have been receiving the best of everything. But that wasn't the way it was at all. Leah even complained to Rachel about stealing her husband.

> *And Reuben went in the days of wheat harvest, and found mandrakes in the field, and brought them unto his mother Leah. Then Rachel said to Leah, "Give me, I pray thee, of thy son's mandrakes." And she said unto her, "Is it a small matter that thou hast taken my husband? And wouldest thou take away my son's mandrakes also?" And Rachel said, "Therefore he shall lie with thee to night for thy son's mandrakes." And*

Jacob came out of the field in the evening, and Leah went out to meet him, and said, "Thou must come in unto me; for surely I have hired thee with my son's mandrakes." And he lay with her that night. And God hearkened unto Leah, and she conceived, and bare Jacob the fifth son. And Leah said, "God hath given me my hire, because I have given my maiden to my husband": and she called his name Issachar. And Leah conceived again, and bare Jacob the sixth son. And Leah said, "God hath endued me with a good dowry; now will my husband dwell with me, because I have born him six sons": and she called his name Zebulun. And afterwards she bare a daughter, and called her name Dinah (Genesis 30:14-21).

After all this time and effort, Leah is still struggling to get the respect and attention that she should have just because she is Jacob's first wife. But it's just not happening for her. She has to buy the attention of her husband from her younger sister. Leah still produced seven children, seven being the number of completion. Leah, the hated one, completed her destiny while her sister Rachel, the desired one, was still struggling, living in deception.

Let's take a deeper look at what happened that disrupted order in the lives of this family.

CHAPTER 3

No Weapon Formed Against You Shall Prosper

THE IMPORTANCE OF THIS CHAPTER can't be expressed enough. Recognizing what disrupts the order of your life is only the beginning. After you recognize it, you must then prepare yourself to deal with this newfound revelation in the light of God's Word.

Now if Leah had been privy to this information that you are about to receive, she would have saved herself and her household a lot of grief. To begin with, she could have allowed God to teach her how to deal with rejection. Then she wouldn't have felt the need to contend with her younger sister for what already belonged to her, thus not allowing herself to be provoked into doing things she wouldn't have done otherwise.

But now that you are arming yourself for the battle with understanding, you'll be able to meet the enemy on your terms, I should say, on God's terms and defeat him.

It's already been said that envy, jealousy, manipulation, and control are detrimental to the life of a believer. It's clearly

demonstrated here in the lives of Leah and Rachel. Because of these spirits, they both walked in deception. Deception led them both to believe things that weren't true and led them to do things they would normally not have done.

If we search our own hearts, we'll see the same is true in our lives. Whether these spirits work through us or against us, the anointing of the Holy Spirit is here to destroy the yokes of bondage that keep us from walking in God's perfect order for our lives; bondage keeps us from fulfilling our purpose and destiny.

We are going to begin by dealing with something the Word of God calls the image or the idol of jealousy. We're led to believe that jealousy is an emotion. It's often said that the biggest deception of the enemy is getting people to believe he doesn't exist. If we believe that jealousy is an emotion, we'll never deal with it in accordance with God's Word, allowing it to continue to destroy our lives and the lives of those around us. This passage of Scripture also speaks of the abominations and great abominations done by the people where the spirit of jealousy was allowed to rule unchallenged. We'll learn more about that and how to be set free.

> *And He put forth the form of an hand, and took me by a lock of mine head; and the spirit lifted me up between the earth and the heaven, and brought me in the visions of God to Jerusalem, to the door of the inner gate that looketh toward the north; where was the seat of the image of jealousy, which provoketh to jealousy. And, behold, the glory of the God of Israel was there, according to the vision that I saw in the plain. Then said He unto me, "Son of man, lift up thine eyes now the way toward the north." So I lifted up mine eyes the way toward the north, and behold northward at the gate of the altar this image of jealousy in the entry. He said further-more unto me, "Son of man, seest thou what they do? Even the great abominations that the house of Israel committeth here, that I should go far off from My sanctuary? But turn*

thee yet again, and thou shalt see greater abominations" (Ezekiel 8:3-6).

Here, Ezekiel is in his house having a prayer meeting with the elders of Judah. An angel appears to him and takes him, in the spiritual realm, "to Jerusalem, to the door of the inner gate...where was the seat of the image of jealousy, which provoketh to jealousy."

Before we go any further, I want you to understand the word "provoke." To provoke means to excite you to an action or feeling. In other words, the spirit of jealousy can provoke you to an action or feeling: to make you do, say, think, or feel something that's not normal to you. There is no other spirit in the entire Bible that has the ability to provoke you.

This is how it was in the case of Leah and Rachel. Remember, they were sisters, they grew up together, they knew one another. No doubt they looked after and cared for one another as children. But the minute a smooth-talking man entered the picture, all of the love and concern they had, or pretended to have, for one another flew out the window.

This opened the door for the spirit of jealousy, which provoked them into competing against one another. Instead of allowing jealousy to provoke us into competing against one another, we should allow the Spirit of God to provoke us into walking in holiness. That's the true essence of this message, to provoke you to walk in holiness.

I'd like to clarify that if this spirit has been operating through you, you can get delivered right now by calling on the name of Jesus, our deliverer. The anointing is right here; just open your mouth and repent. However, if this spirit has been operating against you, hindering you, keeping things from coming to pass in your life, and you're totally unaware that jealousy has been there all the time, it's time for you to open your spiritual eyes to the truth of God and get delivered.

For the most part, you know that something is wrong, but you're unaware that it is jealousy, so you begin to pray and bind up things, but often it's the wrong thing. That's like having a headache and instead of taking something that's formulated for a headache, you rub Ben-Gay on your forehead. Ben-Gay is an excellent topical analgesic for pains in your joints. But it does nothing for your headache. As a matter of fact, before long, things will get worse. Soon your eyes will begin to burn, then tear up. Your sinus passages will begin to burn, and before you know it you'll need something to take care of the symptoms you've just created.

So, before going on, let's get some understanding and deal with jealousy. For someone to be jealous means they are resentfully envious of you. Jealousy works in your soul, causing feelings of discontent or ill will because of another person's advantages or possessions. It's a desire for something belonging to another person.

If someone is envious, they don't think anyone should have anything. It's general: "nothing personal." However, if someone is jealous of you, it's personal, very personal. They personally don't want you to have what you have because they want it.

Jealousy is so serious Ezekiel refers to it as an idol. An idol is a false, mistaken idea or opinion. Also, an idol is false reasoning, or an illogical or misleading argument. The reason a false, mistaken idea or opinion is an idol is because we lift it up over the truth. In other words, if God tries to reveal the truth to you, you'll fight God, who is truth, to protect the lie that you believe to be true.

The truth was that Leah was married first; in essence that makes her the "queen bee." But because her husband rejected her the morning after their wedding night, she believed herself to be unworthy. There Leah was, producing one baby after the other. Then Rachel gave Jacob her maid, and she has two children. Then Leah, the first lady, felt the need to compete with her sister's maid, so she gave her maid to Jacob, and the maid also has babies. This

competition goes back and forth between the two of them, and it's fueled by jealousy.

However, for Leah, this goes deeper than just competing with her little sister to find out which one of them can have the most babies: "Is it a small matter that thou hast taken my husband?" (Gen. 30:15). Even though Leah was married, and even though Leah was the first wife, she knew that Jacob did not truly belong to her, for his heart belonged to Rachel.

Where did this all begin for Leah? "Leah was tender eyed; but Rachel was beautiful and well favoured" (Gen. 29:17). Leah was cross-eyed and obviously not all that attractive, so the door was opened to feelings of worthlessness and low self-esteem. Her younger sister's being "beautiful and well favored" only added to the negative way Leah viewed herself.

No one knew how to stand against this so that Leah could grow up with a healthy respect for herself. So she grew up believing she was worthless. The ultimate act of betrayal was her husband running out of their bedchamber after their wedding night.

Look, if you don't take a stand and put a stop to this stuff, it will continue to work through you and the lives of your children. You'll be thirty or forty years old, still wondering why things aren't happening for you. God tells you you're going to own your own business and be a millionaire, and you're constantly stepping back from the promise while someone else steps over you to receive it, because you still don't know who you are.

God handpicked Leah to be Laban's firstborn daughter, not Rachel. Therefore, it was God's plan all along for Leah to become the mother of destiny. But because she couldn't get past the hang-ups and negative emotions of her childhood, she couldn't see herself as the mother of destiny that God had created her to be.

This could be taught in so many different ways, but let's bring it a little closer to home. Let's say, for instance, we have two little

white girls, sisters, one with blond hair and blue eyes, the other with brown hair and brown eyes. Their mother dresses them up in identical outfits and takes them to church. Who do you think everyone is going to flock to and make a big deal over? The sister with the blond hair and blue eyes.

These are illogical ideas that are embedded into society and used to build a foundation of false reasoning between the two little girls. The dark-haired girl begins to wonder what's wrong with her, while the blond-haired girl wonders why the dark-haired girl doesn't like her or won't be her friend. And it's nothing that either of the girls has done. It's our society and the foolish way we think things ought to be, which is contrary to the way God says it should be.

That exact same scenario is played out in the black community time and time again. You have two little girls, sisters, dressed identically for church. However, one has light skin and long, wavy hair. The other one has dark skin and short hair that's hard to manage. Who do you think everyone is going to flock to and make a big deal over? And who do you think is going to feel shunned and worthless, and wonder why no one likes her or thinks she's special? Which one do you think is going to grow up full of hatred and resentment because she wasn't treated with unconditional love and acceptance because of the way she looked?

You can witness the exact same scenario in the Hispanic community. Whichever one of the two has the more ivory skin tone and lighter hair will be the one everyone will always make a big to-do over, leaving the little girl with the brown skin and dark hair wondering what's wrong with her.

What about weight? You know how it works: You have two daughters, and one is heavier than the other one: one is a size 4 and the other a size 14. You dress them up and take them to church, and everyone ignores the one that's a size 14 and raves over the one that is a size 4. Then we're left wondering why our children are bulimic and anorexic.

Why does this happen? Because society has programmed us to think that something is cute and it's not cute or that something is ugly and it's not ugly. One can be cute, but why can't the other one be cute also? Why can't we see the beauty and value in both of them? Why can't we praise both of them and celebrate their differences?

We make idols out of the little blond-hair, blue-eyed girl; the little black girl with light skin and long, wavy hair; the little ivory-skinned Hispanic girl; and the little petite size 4. They have been made an idol because of an illogical way of thinking and false reasoning. They didn't ask for it; it was put on them. If the truth be known, they really don't want it.

In reality, it doesn't matter what side of the situation they end up on; someone is going to get hurt. You have little girls believing they are something God never called them to be. Whichever side they end up on, they'll always find themselves pitted against whomever is on the other side.

The only thing they want is unconditional love and acceptance. But they've never seen it demonstrated toward them, so they don't know how to give it to the next generation, so this thing is passed down to the next generation.

You maybe wondering, "How could this happen in the Church?" Let's go back to our Scripture in Ezekiel: "And brought me in the visions of God to Jerusalem to the door of the inner gate that looked toward the north; where was the seat of the image of jealousy, which provoketh to jealousy….So I lifted up mine eyes the way toward the north, and behold northward at the gate of the altar this image of jealousy in the entry." See, for them, back in Ezekiel's day, the seat of the image of jealousy was in the temple. However, for us, it's in the Church. Things haven't changed that much.

Therefore, our little girls either grow up in church or, as adults, come to church and receive salvation, and the spirit of jealousy is waiting right there at the entryway. At some point, they are all going

to end up at the altar where the seat of the image of jealousy is located that provokes them to jealousy, and they don't even realize it.

And long before they can ever get delivered from years of being pitted against other women in one form or another, jealousy is right there, provoking them to think and do things they wouldn't normally think or do.

While they're at the altar with their heads bowed giving their lives to Christ, they're wondering what others think of them. Or, they're looking at the shoes on the woman next to them wondering, "Where did she get those?" Or something simple like that.

They truly came to the altar with the intent to give their hearts to Jesus, and they do. However, jealousy is there continually provoking them. Now we're left competing with one another in the Church. It doesn't just stop at shoes, clothes, and who has the latest hairstyle. It goes far beyond that to the point of competing for the attention of the pastor, or those in authority, to the point you're competing for jobs, positions in the workplace, and for men.

Which brings us back to Leah and Rachel. If someone had put a stop to this behavior when they were children by celebrating both of them, the idol of jealousy would have had neither of them to provoke. You are going to have to rise up and take authority over this thing and break its hold off your life and off your family.

I had to do this in my own life and with my own children. I have five beautiful children, four daughters and a son. My first daughter and son both have lighter complexions. We used to go places, and people would ask who I was. Some family members would ignore me because I didn't have light skin. They would make a big fuss over the children and their father and act like I wasn't there.

This really hurt me. I had been rejected because I wasn't as light as the other members of the family, and they were putting me down. It was almost like they were trying to take something from me by not acknowledging me as the mother of my babies. I had

given birth to those babies. They came out of me. I wasn't concerned with the color of their skin or their hair. How dare someone try to take something away from me that God had given me just because I didn't fit the stereotype of someone's false reasoning!

So because of the hurt that I felt, I did something that had I known about the idol of jealousy I would not have done. I prayed that the next baby would be dark like me, and she was. I'm being real with you. I'm showing you how we get into situations because I know that some of you have made similar mistakes.

Then I had something else to deal with; we would go places, and people would always pick out the two with light skin and talk about how pretty they were and would ignore the baby that had the darker complexion.

I actually saw people trying to pit my children against one another. I had to work with my daughter so that she would know her self-worth because people were trying to make her feel that she wasn't as cute as her sister and brother because of the color difference.

I had to work with her to break the spirit of rejection off of her and to help her realize her self-worth. She is an absolute jewel. She has a darling face, she's got gorgeous hair, she has a fantastic figure, and she's smart as a whip.

But when we would go places, because she was darker, people would rave over the other two children and try to push this rejection on her. I would stand up and say, "Oh no, all my children are beautiful." I would immediately counter that thing, not allowing it to take root.

Studying this, I remembered when my fourth child was born and didn't have long hair. My first two girls had long hair, and my son had the thickest hair in the group. Then one was born who didn't have long hair, and she was dark like me because my prayers worked.

I remember people saying, "Well, there's finally going to be a daughter that doesn't have long hair." I'd stand up and say, "No

there's not. Her mother and father have hair. Hair is not a problem in this family, and she's going to have hair, too."

The Lord showed me that if I hadn't stood up and spoken those words over her, she wouldn't have hair, and she would have thought something was wrong with her because the other children did.

Don't you ever allow people to pit your children against one another—or against any other children, for that matter. I didn't understand where it came from until I started studying this. I didn't understand how inbred it was. I didn't understand how in 1965, going to an all-black college, this could affect me. I had a darker complexion, and they actually said to me, "We're going to let some black people like you be in the queen's court this year." I was sitting there, looking at them, thinking, "You're just as black as me." I didn't understand that this thing had been programmed into our society. I didn't understand that people had actually been programmed to think like that. And if you don't stand up and say something against it, those spirits will work against you even though you don't think that way.

I believe that I've given you enough understanding for you to begin to know how to break this out of your life and the lives of your children. It's time to pull down false thinking, false reasoning, and il-logical ideas that you have exalted against the knowledge of God, submerging all of that into the blood of Jesus and opening your mouth to pull down those strongholds and deny them access to your lives while you continue to speak the Word of God that will build up the plan of God for you. So let's get back to Leah and Rachel.

CHAPTER 4

God's Perfect Order Reigns

NOW YOU HAVE SOME REAL INSIGHTS into the root of the trouble between Leah and Rachel. You should also have some insight into things that have gone wrong in your life. You should be able to pinpoint the problem by now. But just in case you can't, ask God to open your eyes through the power of the Holy Spirit.

I need to warn you of one thing: when the Holy Spirit reveals to you the root cause of the spirit of jealousy that's been operating through or against you, you may not want to believe the revelation. The first thing you're going to say is, "That can't be true." If the Holy Spirit is revealing it to you, then it's the truth, and it has to be dealt with.

It's only after you begin to deal with the truth that you'll begin to walk in the freedom and dominion that God always intended you to walk in. And only then will you be able to complete your destiny the same way Leah completed hers. But before we go there, let's take one last look at Rachel.

And God remembered Rachel, and God hearkened to her, and opened her womb. And she conceived, and bare a son; and said, "God hath taken away my reproach": and she called his name Joseph; and said, "The Lord shall add to me another son" (Genesis 30:22-24).

And they journeyed from Bethel; and there was but a little way to come to Ephrath: and Rachel travailed, and she had hard labour. And it came to pass, when she was in hard labour, that the midwife said unto her, "Fear not; thou shalt have this son also." And it came to pass, as her soul was in departing, (for she died) that she called his name Benoni: but his father called him Benjamin. And Rachel died, and was buried in the way to Ephrath, which is Bethlehem. And Jacob set a pillar upon her grave: that is the pillar of Rachel's grave unto this day (Genesis 35:16-20).

All this time, Jacob had struggled with Rachel, his desire, and now she died in childbirth, giving him his last child. She named her son Benoni, which means son of foolishness, son of mischief, son of misery, or son of folly. Then Jacob changed his name to Benjamin, which means "son of my right hand." Perhaps Jacob was the one struggling now. The love of his life had just died giving birth to his last child and named him son of foolishness; and Jacob changed his name. This was the love of his life, his heart's desire: how was it possible that anything they had created together could be foolishness? Perhaps he was still not ready to face the truth.

Have you ever discovered that God wasn't in something and you tried to name it something else? You clearly saw that you'd made a mistake and that you ended up in a mess, but you were too proud to admit it, so you decided to give it another name. You came at it from a different perspective. You cannot decide to bless something God has not blessed. The best you can do is fall down on your face and ask God to bless it. If He doesn't, it will never be blessed.

When God told Abraham that Ishmael wasn't the seed of promise, Abraham asked God to bless Ishmael, and He did. Jacob has not once asked God to bless anything that he's gotten himself into.

Rachel died—the one Jacob had loved and desired, the one that he worked fourteen years for. You know this must have been some funeral. Can you imagine how Jacob must have mourned her? I mean, we know everything he went through to get her. The Bible says that he set a pillar upon her grave; that is the pillar of Rachel's grave until this very day. He must have made a monument to her. This was the love of his life, the one he desired. But what happened to the one that he personally hated? What happened to the one that he rejected the morning after their wedding night? What happened to the one that produced his destiny and completed hers?

> *And he charged them, and said unto them, "I am to be gathered unto my people: bury me with my fathers in the cave that is in the field of Ephron the Hittite, in the cave that is in the field of Machpelah, which is before Mamre, in the land of Canaan, which Abraham bought with the field of Ephron the Hittite for a possession of a buryingplace. There they buried Abraham and Sarah his wife; there they buried Isaac and Rebekah his wife; and there I buried Leah"* (Genesis 49:29-31).

This is at the end of Jacob's life. His name has been changed to Israel. He's now ready to die. It's interesting to look at his life from the time he was a young trickster, to the present, after he's been with God. He's a man who had been through some struggles and now he has understanding and wisdom. He's giving his sons instructions as to where to bury his body. We know that when Rachel died, he dedicated a pillar to her, so you would think he would want to be buried with her, but he didn't.

Jacob was to be buried in the tomb that was purchased by Abraham. It could only hold six bodies, and the promise was to Abraham, Isaac, and Jacob, and their wives. In order for the promise to be fulfilled, Jacob had enough sense to put Leah, his destiny, in that

grave. If he'd put Rachel there instead, he would have messed up the promise for future generations. It wasn't over when Jacob had his twelfth son. It wasn't over until he completed his assignment, and that entailed being buried in the tomb that Abraham had bought, next to Leah.

Jacob instructs his sons to bury him with his purpose, realizing at the end of his life that the only thing that matters is what God called him to do. He realized that everything that he had desired, everything that he thought was so wonderful, everything that had gotten him into trouble, didn't matter. The only thing that mattered was his purpose. That's where he wanted to be buried. He understood that he had been through the fire and the flood, and the only thing that remained was his purpose. His purpose had been fueled by order.

Leah went to her grave thinking that she was a second-class citizen in the eyes of her husband, the one that was supposed to love, cherish, and protect her. I'm sure that she felt unworthy and that her life had no meaning. However, Jacob's instructions to his sons were to bury him with what he didn't love, with what he hated. He wanted to be buried with the thing he had rejected all those years.

Don't live your life like Leah did, allowing the enemy to make you think that because you're going through something, you are not walking out your purpose. Don't you let the enemy make you think that just because you're not where you said you would be, or where you felt God wanted you to be, that you're not in the center of God's will for your life. Jacob missed it big time, and God still perfected his destiny.

You could almost be left with the impression that desires are wrong, but that's a misconception. God will give you the desires of your heart, but your heart must be clean. Just like when Jacob arrived to live with his uncle, he knew that he needed a wife. But he went about it the wrong way. There are a lot of single people who desire to

be married. That's a good thing to desire. But if you want someone that is not in the will of God for you, you'll be struggling forever.

When you walk in purpose, and now we can add order to that, natural and spiritual laws will line up for you. The flip side of that is when you choose to supersede God's laws of order for your life, not only you, but your family and all those around you, will pay the price.

You may be willing to compromise God's laws, but your destiny will never be fulfilled unless you get your life in order. Your destiny isn't just about you or the people around you, but it is tied to every generation that comes after you. While you're busy compromising, you're not building a strong bridge for them to walk across.

Even your seed won't be able to reach their place of destiny because of your willingness to compromise, living outside of the boundaries of order and having to have things your own way. You must recognize that we've entered a new dispensation, a new way of doing things, and it truly is going to be God's way or no way at all. God's way begins and ends with order.

IMPARTATION IV

Asset

Asset

THE ENTIRE BASIS OF D.I.V.A. IS to show God's women everywhere just what God's original plan is for them, which brings us to the final phase of development: Asset. Yes, D.I.V.A., even though you would have never believed it to be true, you are an asset. You are an asset to God first, to yourself second, to your family third, then to your community and the world as long as you remain in a right relationship with God.

There is an advantage to your being in right relationship with God. The benefits that this relationship brings to your life will spill over into the lives of those around you. So there is an advantage to them being in right relationship with you. I can hear you saying, "How is it possible for it to be an advantage for them to be in right relationship with me? I'm not all that important."

Yes, D.I.V.A., you *are* all that important—and then some.

Remember, we don't want to end up in the ditch on either side. We are going to remain balanced, right down the center of the

road. It's time for the women in the Church to stand up and be whole. I say that cautiously because I don't want anyone to think I'm saying women rise up in opposition to men. I talked to the Lord about this, and He said, "Neither your heart nor your spirit is saying that, so just say what I told you to say; it will not come across negatively."

Then I realized that it's not in opposition to anything except the devil. He has tried to hold back the women of God since the garden, but we're going to break his hold over our lives forever.

You Can Change Your Future

D.I.V.A., YOU ARE IN A NEW SEASON called transition. In this season, you will be changed from one fixed position to another. We all know that we're creatures of habit who hate to change. But until you're willing to make that change, you won't be able to get to the next level in God.

The vehicle that will be taking us through this transition is called the glory. The suit we're going to wear in the vehicle is called prayer. I want to show you how a little, seemingly insignificant woman named Rizpah, hidden between the pages of the Second book of Samuel, interceded on behalf of something already dead and changed the destiny of a generation of people for eternity.

Then there was a famine in the days of David three years, year after year; and David enquired of the Lord. And the Lord answered, "It is for Saul, and for his bloody house, because he slew the Gibeonites." And the king called the Gibeonites, and said unto them; (now the Gibeonites were not of the children of Israel,

but of the remnant of the Amorites; and the children of Israel had sworn unto them: and Saul sought to slay them in his zeal to the children of Israel and Judah.) Wherefore David said unto the Gibeonites, "What shall I do for you? And wherewith shall I make the atonement, that ye may bless the inheritance of the Lord?" (2 Samuel 21:1-3)

David had only been king for a short while. There was a famine in the land. The mark of a good king is how well his people are taken care of. With a famine in the land, it didn't look all that good for David. Like any good king, he recognized his inability to remedy the situation, and he went to God for answers.

This is something we could all learn a lesson from. When we get in a fix, we should ask God how we got in it. What we normally do is jumpstart the thing and ask God how to get out of it. We get a temporary solution with instant gratification, but the situation is not settled. You'll be tempted and end up back in the same fix because you don't know how you got in the thing in the first place. The door remains open for it to come back on you.

This all begun when the Israelites made a covenant with the Gibeonites. Saul had gone back on that covenant or agreement and sought to destroy their entire nation. Even though we take it lightly, entering into a covenant is a serious thing, especially to God. We serve a covenant-making and covenant-keeping God. It's no light thing for the people of God to enter into a covenant, whether you're entering into it with other people of God or unbelievers.

It is not a light thing with God. Even though the Gibeonites were not a part of God's covenant people, God took the covenant made with them seriously. It's never a good thing for you to break the covenant for any reason. A famine was brought on the land because Saul broke the covenant. I wonder sometimes if a famine hasn't been brought on the Church because we've made covenants and not kept them.

David does a good thing by going to God and asking why there had been a famine in the land. However, he makes a real big mistake. He doesn't ask God how to rectify the problem. He immediately goes to the cause of the problem, asking what will it take to make things right. The men of Gibeon knew exactly what they wanted.

> *And the Gibeonites said unto him, "We will have no silver nor gold of Saul, nor of his house; neither for us shalt thou kill any man in Israel." And he said, "What ye shall say, that will I do for you." And they answered the king, "The man that consumed us, and that devised against us that we should be destroyed from remaining in any of the coasts of Israel, let seven men of his sons be delivered unto us, and we will hang them up unto the Lord in Gibeah of Saul, whom the Lord did choose." And the king said, "I will give them"* (2 Samuel 21:4-6).

The men of Gibeon asked for the lives of seven of Saul's sons, and David agreed. Saul had five grandsons by Michal and two sons by Rizpah. It was Rizpah who changed the destiny of her family. Now, you're going to learn to do the same.

It doesn't matter what your future looks like. You have the power to change it in God. I don't care what your grandmother said your future was going to be. I don't care what your circumstances have said your future should be. God has a future for you that is settled in Heaven, and that is the future you're going to walk in. Things are being rearranged in the atmosphere because in this hour you can't afford to miss it. God is holding up time and sequential events in your life so that you are on target and in place, exactly where He wants you to be and when He wants you to be there.

David makes this monumental mistake and gives the Gibeonites the seven sons of Saul. The number seven represents atonement and completion, and the seven sons symbolized total inheritance. It now looked as though the sins of Saul had been atoned for and the total inheritance and future of the family line had been lost. However, someone was willing to pay the price in prayer.

Rizpah was a concubine and considered a second-class citizen. But being married to the king did afford her some privileges, not like those of Saul's first wife, the queen. But Rizpah was still counted among the privileged. She got to live in the palace. She was intimate with the king. She had servants who attended to her personal needs, and she wore the finest clothes. She lived the life of royalty.

Even though she was a concubine and considered a second-class citizen, we can learn two very important things that will help us endure during our season of prayer. The Scripture tells us this:

> *But the king took the two sons of Rizpah the daughter of Aiah* (2 Samuel 21:8).

Whenever the Bible tells us of someone's genealogy or family history, it is telling us that there's a connection in the family of God. For Rizpah, it's saying that she wasn't just a concubine, a second-class citizen; she was a descendant of Abraham, and she still had rights and privileges that marital status couldn't take from her. She understood these rights because she had a father, Aiah, who'd taught her of her inheritance ever since birth.

It is a lesson we in the Body of Christ could stand to learn. We are the spiritual seed of Abraham, engrafted into the family through the blood of Jesus. We have rights and privileges that we haven't even begun to appropriate.

The second point I want to make is that in the Word of God, whenever God uses a woman for a certain example, it's to show you how quickly a thing can reproduce itself. Women are the reproductive agents of God. Whenever you see a spirit attached to a woman, it's not just about the woman. Spirits are neither male nor female. God is simply demonstrating how fast something can reproduce itself.

Take, for instance, the spirit of Jezebel. This spirit is the spirit of manipulation and control. We know that there are men who can be just as manipulative and controlling as some women are. The reason the spirit is identified on a woman in the Bible is because it

can reproduce itself very quickly. You need to take authority over it and kill it. Rizpah did a good thing that reestablished the heritage of her family. Therefore, this can also reproduce itself quickly, and that's what we're going to do.

This is a message for prayer warriors and those of you with enough tenacity to hang on until you receive a change. The way you've prayed in the past has laid a foundation for where you're going in the spiritual realm.

May I tell you that it is no longer about you praying, but it's all about you becoming a prayer. It's not about you crying out to God anymore; it's about you becoming a cry out to God. It's not about you praising God anymore; it's about you becoming a praise unto God. That's the season that we've moved into. That's the anointing that's on your prayer life.

Now God can take you from one level of the court of Heaven to the next level because you're going to become a prayer. When you become a prayer, you don't have time for all those old things that use to waste your time any more. It's not that any of it was sin, you just don't have time for it anymore.

And he delivered them into the hands of the Gibeonites, and they hanged them in the hill before the Lord: and they fell all seven together, and were put to death in the days of harvest, in the first days, in the beginning of barley harvest (2 Samuel 21:9).

Rizpah has lost the king, her position, and now her sons. She's now become chattel; it was as though she had become part of the estate. She had lost every single thing. Now her sons were hanging from the gallows for all the community to see. Since she was willing to become a prayer, she set in motion the opportunity to change lives in the twenty-first century.

It says that this was during the time of a famine in the land. However, it was the first days of the barley harvest, so the community was going out to see what there was, if anything, to harvest.

But what they saw was the seven sons of Saul hanging dead in the fields, and something even more amazing.

> *And Rizpah the daughter of Aiah took sackcloth, and spread it for her upon the rock, from the beginning of harvest until water dropped upon them out of Heaven, and suffered neither the birds of the air to rest on them by day, nor the beasts of the field by night* (2 Samuel 21:10).

Allow me to help you get an understanding of what was going on. The people would begin to harvest barley in late April or early May. The harvesting season lasted until October. She was interceding over seven dead boys, five of whom weren't even hers, for about five solid months, never moving from her post.

This is a symbolic picture for the Church. For five months she didn't budge from her position, from the end of April through May, June, July, August, September, and the beginning of October. Can you imagine all the different weather conditions that she had to endure—the dry, dusty heat in the day, the frigid cold at night?

Here was a woman used to living the high life, a person who was used to having different people around her all hours of the day or night to make sure her every need was met. She was living outside in the barley fields, praying and wailing, and taking on sackcloth for seven dead boys. Everyone in the community watched her. She refused to be comforted or moved from her post. But more importantly, she didn't care what others thought of her.

The Scripture says she fought the birds of the air by day and the beasts of the fields by night. The birds represent the distractions that come against you when you decide to pray. You know how you remember every little thing that you need to do when you decide you're going to pray. Then the phone rings, and you must answer it. It's always those well-meaning folks that just want to remind you that whatever you're praying for is a dead issue and how it's still hanging out there in disgrace for all the community to see. They will accuse you of wasting all your time

praying, like you must have missed God, or there's no way God is in the middle of all that confusion.

None of that mattered to Rizpah. She still refused to move from her post. She understood that somebody had to be willing to pay the price in prayer. She would if she looked stupid, even if no one else understood, even if no one else came and joined the prayer meeting because it wasn't a convenient time for them to pray, and even if she had to pray for more than twenty-four hours.

You know, if some of us pray and don't see results in twenty-four hours, we think that God has failed us. This woman prayed for five months!

The Scripture talks about how she had to beat back the beast of the field by night. She had to stop them from stealing her family's destiny. You're going to have to do the same. Nighttime is the time when no one else is around you. Even if you're married, nighttime is when you go through all by yourself. You're there all alone. It's just you and whatever is on the inside of you.

If you haven't prayed during the day nor meditated on the Word of God, then there is nothing there that you can pull out in the midnight hour to fight the attacks of satan against your mind. Nighttime is the time when fantasies begin to run through your mind. It's almost as if they have a life of their own. The enemy would try to make you believe that you have no control over what you're thinking, but that's a lie. The enemy begins to tell you every possible scenario, and you begin to visualize every twist and turn until you can see that thing coming out with an evil ending.

But during the day, you are going to gird up your mind with the power of God's Word. Then at midnight, when the beasts of the field come to eat up everything that you're fighting for, you're going to take the Word of God that you've meditated on all day and beat him back.

Rizpah paid a heavy price so that her seed would not come to shame. The sentence had been passed. The Gibeonites had wiped out all seven of Saul's sons. Why should she pray over something that's already dead? She wasn't even praying to bring them back to life. She was praying to change her future. She was praying so that what the Gibeonites said was going to happen to her seed and their inheritance would not happen. She didn't have time to worry about anything for those five months while she was praying over something that appeared in the natural to be dead. She was determined to change eternity.

Some of the things you will be praying for are not for just you and your four and no more, it's for future generations. Some of the people God wants you to intercede for and rearrange things in the spiritual realm for are not even in the Kingdom yet. Some of them aren't even born yet, but God has placed you there so that they might have a future and an inheritance.

Rizpah has now become a prayer. The Scripture never tells us that she ever opened her mouth to speak a single word. However, it does say she got results. There's a process in becoming a prayer, and that's what she became: prayer. Her determination became a prayer. Her posture became a prayer. Her beating back the birds by day and the beasts by night became a prayer. Her refusal to move from her post became a prayer. Her willingness to endure the elements became a prayer. Her willingness to endure humiliation became a prayer. Since everything about her became a prayer, she became a prayer.

If you're going to ride in this vehicle called the glory, if you're going to put on this suit called prayer, if you're going to move into this transition that God is taking the Church into, you're going to have to not care about how you look. You're going to have to not care about who it adds you to or separates you from. You're just going to have to do what God has called you to do.

We're at the end of our story, so let's see exactly how Rizpah changed the destiny of her family forever.

And it was told David what Rizpah the daughter of Aiah, the concubine of Saul, had done.…And he brought up from thence the bones of Saul and the bones of Jonathan his son; and they gathered the bones of them that were hanged. And the bones of Saul and Jonathan his son buried they in the country of Benjamin in Zelah, in the sepulchre of Kish his father: and they performed all that the king commanded. And after that God was intreated for the land (2 Samuel 21:11;13-14).

When Rizpah decided in her heart that she would become a prayer, the king heard about what she did. When you decide to become a prayer (I'm not talking about what you do for show so others can hear and know what you've been doing; I mean when you make the decision that no matter what is going on in your life right now you're going to get on your face before God in determination that you're going to make a difference in somebody's life that will affect their future), then your King is going to hear about it.

When David heard what Rizpah was doing, he sent men out to get the bones of Saul and Jonathan and the seven that were hanged and buried them in the sepulchre of Kish, Saul's father. The significance of this is the Word of God says anyone that hangs on a tree is cursed.

His body shall not remain all night upon the tree, but thou shalt in any wise bury him that day; (for he that is hanged is accursed of God;) that thy land be not defiled, which the Lord thy God giveth thee for an inheritance (Deuteronomy 21:23).

By David taking down their bodies, the curse was broken, and by him allowing them to be buried alongside Saul, their father, restoration was brought back to the family line for future generations.

It's now time for you to become a prayer, because somebody's future is depending on you!

CHAPTER 2

The Life-Changing Power of Your Words

ONE OF THE MOST POWERFUL TOOLS or weapons that every D.I.V.A. has in her possession is her tongue.

Death and life are in the power of the tongue: and they that love it shall eat the fruit thereof (Proverbs 18:21).

The words that you allow to come out of your mouth will build up or tear down everything in your sphere of influence.

For in many things we offend all. If any man offend not in word, the same is a perfect man, and able also to bridle the whole body. Behold, we put bits in the horses' mouths, that they may obey us; and we turn about their whole body. Behold also the ships, which though they be so great, and are driven of fierce winds, yet are they turned about with a very small helm, whithersoever the governor listeth. Even so the tongue is a little member, and boasteth great things. Behold, how great a matter a little fire kindleth! And the tongue is a fire, a world of iniquity: so is the tongue among our members, that it

*defileth the whole body, and setteth on fire the course of na-
ture; and it is set on fire of hell. For every kind of beasts, and
of birds, and of serpents, and of things in the sea, is tamed, and
hath been tamed of mankind: but the tongue can no man
tame; it is an unruly evil, full of deadly poison. Therewith
bless we God, even the Father; and therewith curse we men,
which are made after the similitude of God. Out of the same
mouth proceedeth blessing and cursing. My brethren, these
things ought not so to be* (James 3:2-10).

As you've begun to develop the D.I.V.A. within you, it is time
to put away all those things that would hinder your development;
the major obstacle is evil speaking: words, whether founded or un-
founded, that are malicious and hurtful, full of poison, always
yielding deadly results. We must learn to recognize these character
assassinations for exactly what they are: the enemy using us indi-
vidually to cripple the Body of Christ, of which we are a part.

D.I.V.A., you must determine in your heart that from this point
on you'll not participate, in word or deed, in this behavior. It doesn't
matter what's going on around you, you discipline yourself to only
allow righteous words of life to come out of your mouth.

*Who is he that condemneth? It is Christ that died, yea rather,
that is risen again, who is even at the right hand of God, who
also maketh intercession for us* (Romans 8:34).

*Seeing then that we have a great high priest, that is passed
into the heavens, Jesus the Son of God, let us hold fast our pro-
fession* (Hebrews 4:14).

Jesus is right now sitting at God's right hand waiting for some
positive, faith-filled words to come out of your mouth so that He
can intercede on your behalf, no matter what the situation is. Then
God is able to dispatch the ministering angels that are assigned to
you to work on your behalf. But it's only when you give Jesus some-
thing to work with that your angels will go into action and you can
receive help from on high.

Then said he unto me, "Fear not, Daniel: for from the first day that thou didst set thine heart to understand, and to chasten thyself before thy God, thy words were heard, and I am come for thy words" (Daniel 10:12).

The angel of the Lord said to Daniel, "I am come for thy words." I'll say it again: your words either create or tear down your world. The choice is yours.

D.I.V.A., you are going to learn to build your house with the words of your mouth. With the confession of your mouth, you are going to create your environment, the one God always intended for you to live in. Remember, we are in this world, but not of it. The very system that you were taught to manipulate and control with the words of your mouth, you are now going to turn around in total submission to God and work that tongue for the glory of God. We do this because God gets the glory, but we get the goods.

Inasmuch then as we have a great High Priest Who has [already] ascended and passed through the Heavens, Jesus the Son of God, let us hold fast our confession [of faith in Him] (Hebrews 4:14 AMP).

Hold fast to what you know God is saying to you, to what you believe in. Circumstances will always come in your life to make you lose your confession. As soon as you say, "By his stripes I'm healed," sickness or pain is going to go through your body. As soon as you start talking about how the Lord has blessed your finances, don't think you haven't just positioned yourself to get hit in the financial area. As soon as you stand up and give a testimony of what God has said to you, here comes the devil: "Did God really say that?"

You have to hold on to what you know God is speaking to you, no matter what. I was speaking to a couple about moving from another state to become members of my church. I told them to go back home and pray and talk to one another about the situation. Then, when we met a few months later, they began asking me what I thought about certain decisions they had made. I said, "I don't

know, what do you think?" I asked them what God had spoken to them about the situation. They told me they originally believed that God had said certain things to them. I told them that I wasn't getting in it, because it had to be their confession to carry them through this. In the midnight hour, when all the forces of darkness were unleashed against their minds to bring doubt and confusion, it had to be what they believed God had spoken to them that would keep them focused.

It was going to be their faith and what they believed that would get them through the tough times. You have to know what you believe and in whom you believe.

If they hadn't heard from God and I had gotten involved in their situation, and it had not turned out the way that they wanted it to, then they would have wanted to blame me.

> *My son, if thou be surety for thy friend, if thou hast stricken thy hand with a stranger, thou art snared with the words of thy mouth, thou art taken with the words of thy mouth* (Proverbs 6:1-2).

You can plainly see from the Word of God that if you're angry about your present situation, then there is no one to blame but yourself. As long as you are blaming somebody else, you're looking for somebody else to get you out of your current situation. If you're in trouble, it's because you have been opening your mouth, agreeing with the wrong thing.

If you're broke, it's because you haven't been confessing that you're wealthy. If you're sick, it's because you haven't been confessing that you're healed. You have the power of life and death; and it's in your tongue. You can confess your way out of any circumstance that you will ever find yourself in. If your circumstances are good right now, then open your mouth and make them better.

Never wait until you get so deep in the problem that you lose focus before you start trying to confess your way out. The same law

of God will work for you once you're up to your eyeballs in trouble, but why wait? There was a time when my left knee was "trying to act crazy." It would literally go out on me. Before I could get to where I was going, I'd be limping and leaning. I didn't wait for it to go out completely from the first time I felt the slightest pain. I began confessing health and strength over my knees in the name of Jesus.

I'm not going to give in to the discomfort. I'm healed in the name of Jesus, and until I receive the manifestation of what I'm believing for, I'm not going to change what I'm praying or saying.

It's the Word of God that will satisfy and bring health and wealth to you when you're in an otherwise unbearable situation.

> *A man's belly shall be satisfied with the fruit of his mouth; and with the increase of his lips shall he be filled* (Proverbs 18:20).

This Scripture is not talking about literal fruit like apples, bananas, strawberries, and grapes. This means whatever you produce with your mouth should be what satisfies you. However, that's not the case with most members of the Body of Christ. You're not satisfied with the fruit of your mouth because you're either saying the wrong thing or you're saying nothing at all. You need to begin to open your mouth and speak all the wonderful things that the Word of God says about you. This way you're lining up and agreeing with God.

Jesus gives an excellent demonstration of how to change your life with the power of faith-filled words in the Scriptures:

> *And seeing a fig tree afar off having leaves, He came, if haply He might find any thing thereon: and when He came to it, He found nothing but leaves; for the time of figs was not yet. And Jesus answered and said unto it, "No man eat fruit of thee hereafter for ever." And His disciples heard it....And in the morning, as they passed by, they saw the fig tree dried up from the roots. And Peter calling to remembrance saith unto Him, "Master, behold, the fig tree which Thou cursedst is withered*

away." And Jesus answering saith unto them, "Have faith in God. For verily I say unto you, that whosoever shall say unto this mountain, 'Be thou removed, and be thou cast into the sea'; and shall not doubt in his heart, but shall believe that those things which he saith shall come to pass; he shall have whatsoever he saith" (Mark 11:13-14;20-23).

What Jesus is saying to them is, "You have just seen an example of words filled with the God kind of faith." You can now receive it and do the same. Speak to the mountains in your own life, using the Word of God, and watch those mountains crumble.

The God kind of faith says that I can speak to my situation, believing that it will change, because my words create my atmosphere. My words create how I live. My words create my wealthy place. My words create my healing. My words create my deliverance. My words create my joy. This is the kind of faith that speaks to valleys, which represent the dry places of life, and says, "Come up to where I need you to be. I refuse to go down with this thing again. The valley must come up to me. I need some level ground to walk across this thing on."

If you're going to receive anything from God you're going to have to open your mouth and start speaking it into existence. This is a spiritual law that works every time.

Jesus says, "And shall not doubt in his heart." Out of your heart flow the issues of life, the issues of your life.

Keep thy heart with all diligence; for out of it are the issues of life (Proverbs 4:23).

Keeping your heart pure is your responsibility. How do your keep your heart pure? Hint: garbage in, garbage out. If you're feeding your heart a steady diet of fear, doubt, and unbelief, then that's all that will come out. However, getting to the place where you do not doubt in your heart begins with you feeding yourself a continual diet of the Word of God. It is just the vehicle to get you to the point where you do not doubt. When you hear yourself repeatedly

say what the Word of God says about you, doubt can't stay. By that same token, when you hear yourself repeatedly say negative things about you, faith can't exist in that atmosphere.

Every time you release anything negative out of your mouth, you are fanning the flames of fear. You may need to open your mouth and ask God for a new heart or to restore in you a right heart.

It also says, "But shall believe that those things which he saith shall come to pass; he shall have whatsoever he saith." It's just possible you don't have what you want or need because you haven't opened your mouth to ask God for it. If you did this, you would be surprised how God has a way of getting things to you.

You may need or want something as simple as a new dress or something as big as a new house or car. You have to open your mouth and ask. Go to the Word and find Scriptures that line up with you having what you're believing God for. Then open your mouth and get real with God.

How many times have you needed something and said, "The Lord knows." Yes, God does know, but He's the one who said for you to ask Him.

> *Ask, and it shall be given you; seek, and ye shall find; knock, and it shall be opened unto you: for every one that asketh receiveth; and he that seeketh findeth; and to him that knocketh it shall be opened. Or what man is there of you, whom if his son ask bread, will he give him a stone? Or if he ask a fish, will he give him a serpent? If ye then, being evil, know how to give good gifts unto your children, how much more shall your Father which is in Heaven give good things to them that ask him?* (Matthew 7:7-11)

Jesus is saying, "Just ask your Heavenly Father. Get real with Him and ask for what you want." You don't have to use the language they did in the King James version of the Bible to talk to God.

"Father, Thou knowest all things. Thou seest all things. Thou sittest high and lookest low. I bless Thee God for Thou knowest my uprising and Thou knowest my down falling and all my comings and goings. I thank Thee for making a way for me where there seems to be no way. In Jesus' name, amen."

And all the while God is saying, "Duh!"

A prayer like that won't get above the ceiling. Yes, God knows it all, but He's not motivated to respond to you by what He knows. He's motivated to respond to you by your faith-filled words. When you get real with God and open your mouth, you can get some answers.

Now then, if you would dare say, "God You know I'm down in the valley and I can't pay my bills. I'm not getting along with my husband right now. The people on my job are all acting crazy, and You know my boss is messed up, too. My kids, even the grown ones, are acting crazy. Lord, I need You to make a way for me. I thank You that You have already made that way, and His name is Jesus. So right now I bring all those things under submission to Your Word.

"I thank You that You've caused me to be the head and not the tail, above only and not beneath. I thank You that You said that no weapon formed against me shall prosper. I thank you that every spirit that's coming against me has got to bow right now because I'm in line with You, so my family has got to get in line with me. I thank You, Lord God, that Your Word is not going to return void on my behalf. I thank You, Lord, that You are aware of what's going on in the lives of my children and they must line up with your Word. I thank You, Lord God, that You will send Your ministering angels out to watch over them and protect them and to take care of them. I thank You, Lord God, that You give Your beloved sleep and rest because You are taking care of everything that concerns me."

When you get real and begin to pray like that, you begin to charge the atmosphere around you with faith. Then bells and whistles begin to go off in Heaven. Jesus begins to intercede on your behalf, talking to God about your situation. God starts telling the

angels to go here and do this, go over there and do that; then things start shaping up in a way you never thought possible.

So when someone says, "Lord, Thou knowest," and someone else says, "Lord, You promised to watch over everything that concerns me, and You are not a man that You should lie"—which words do you think are filled with faith and will receive results?

Your faith-filled words have created a picture in the spiritual realm, and all the forces of Heaven begin to work to make sure that that picture is developed in your life. When you speak the words that show God that you believe in His Words, He hearkens diligently to perform His Words. When you send His Word to a particular situation that you're going through in your life, He's got to show up on your behalf.

I can't tell you how many times the Lord said to me, "I had to show up on your behalf because all you spoke were My Words." But when you're not saying anything, or when you're saying the wrong thing, He doesn't have to show up.

We just learned how to become a prayer from the life of Rizpah. Now allow me to teach you how to talk trash; this will be from the life of Dr. Terri Smith-Little, Ph.D. I know a lot of you understand what I'm talking about, but just in case you don't, welcome to Trash Talk 101.

See, talking trash isn't so much what you say but how you say it. You know, before you got saved, there weren't too many people who would get in your face. Once you got your eyes fixed, your neck right, one hand on your hip and working the other. It didn't matter what you were saying, folks got out of your way. It was more about your attitude than it was about what was coming out of your mouth. Every one around knew you meant business. You really didn't care who saw you, you were determined to be heard, and nothing else mattered.

For most of us, this only happens when we get fed up, when we get sick and tired of being sick and tired, when they've succeeded in

pushing all our buttons, or when they've gotten on our last nerve. When we've taken all that we're going to take and then just in that microsecond of time, we know beyond a doubt that we're not taking any more.

Wives, stop going to God and saying things like, "Well, Lord, you know, my husband is still acting simple, and I don't know what I'm going to do." Why are you confessing that? Instead, try speaking the Word of God, "My husband is the priest of my home. My husband is the head of my household. My husband is a man of favor because, God, Your Word says, 'He who finds a wife finds a good thing and favor with the Lord.' And he is blessed just because he has me."

You've forgotten how to talk trash. You can take that same trash-talk mentality that you used before you got saved and turn it around and use it on the devil. You'd better get real with God and start talking trash toward the devil and watch the Holy Spirit back up your trash.

Instead of sitting around wondering where your husband is and with whom, learn how to talk trash to the enemy and your flaky mind, and he'll be home with you. Stop sitting around feeling insecure, thinking, "He doesn't love me." When that comes across your mind you'd better stand up and say, "In the name of Jesus I know he loves me, he's not crazy."

You create your world with the words that come out of your mouth. When I was purchasing my house, I used to walk around the property and sit out by the swimming pool in the middle of the night and claim that it was mine.

Now I sit out there in the swimming pool in the middle of the night, and it is mine. I didn't sit out there saying, "Lord, Thou knowest." I said, "Lord, you said everywhere I put my foot…and my foot is here. You gave my foot authority, You gave my foot power and I'm putting my foot down right here on this place because You said it was mine and it's time for a transfer and I command the transfer to take place."

I opened my mouth, and I wasn't bashful either. The Bible says, "The Kingdom of God suffers violence, and the violent take it by force." The only way for you to let God know you're in His Kingdom is by the words that are coming out of your mouth.

Your words are containers that carry faith or fear. Notice I didn't say your words are *like* containers. They *are* containers, and whatever is in your heart will fill those containers as they come out of your mouth, permeating the atmosphere with faith or fear; and at the same time dictating exactly what help, if any, you will receive from God.

Your words are also seeds that produce after their own kind. The sad thing is if you are getting a continuous crop of things produced by fear, then everyone around you will partake of that crop. Your children, other family members, people on your job, friends, and neighbors all look to you because you are quite possibly the only Christian in the family, or that they know. They're looking at what's being produced in your life. They are thinking, "Why should I serve your God? I'm doing better than you are without any God at all."

So if your words are, "I hope; I may; one day; I wish; I might" then that's all you're ever going to have. You're going to have a big crop of it, too, because we're in acceleration and everything is producing faster than you ever imagined.

But if you're planting words full of faith, the words that God has said about you, those words are going to produce after their own kind also at an accelerated pace, and you never get back less than you plant, because God is a multiplier.

However, maybe you don't say enough to get back anything. You can identify where you are by whether you are living off the top or just barely getting by. You may need to inundate the atmosphere with faith-filled words. You need to wake up saying you're blessed. You need to go to sleep saying you're blessed. You need to take time during the day just to say you're blessed. While driving

your car, you need to stop wondering what's going on at work or at home or with Aunt Susie across town, and begin saying you're blessed, and you can't be cursed.

Let your words create something for you. I promise you unequivocally, based on the Word of the living God, that you are in a season where the sky's the limit for your life. Yes, you're being tested and tried, but doesn't all precious metal go through a time of testing? Don't all precious stones have to go through pressure before their true value can shine through?

Remember, you're a precious stone, a D.I.V.A. cut. You were cut directly out of the heart and mind of our Creator, Jehovah Elohim. Before He created anything, He first opened His mouth and released words full of faith and power. His Words never return to Him void. Now it's time for your words to stop returning to you void.

D.I.V.A., you're now going to open your mouth with the God kind of faith and begin releasing words to produce results.

CHAPTER 3

Your Answer Is in the Fire

For promotion cometh neither from the east, nor from the west, nor from the south. But God is the judge: He putteth down one, and setteth up another (Psalms 75:6-7).

To every D.I.V.A. who has begun the process of developing what God has placed in you, please note: all hell has been put on alert. Alarms are going off in the realms of darkness, and demons are being brought to attention because of you. They are lying in wait to see if what you've just read is going to stir anything within you. They are waiting to see if you actually believe the information you have just received, and if you are willing to put forth the effort to cultivate these new principles and apply them to your life. Because once you've walked through deliverance and proven yourself with obedience, there is always going to be a time of testing to see if you can actually stand after having done everything you know to do. Don't fret, because after this time of testing, promotion is not far behind.

Once you begin to walk in the truth that you've learned, it doesn't take long for you to see the evidence of change, and it doesn't take the enemy long to organize a counterattack with the sole purpose of getting your eyes off the joy or prize that God has set before you.

> *Looking unto Jesus the author and finisher of our faith; who for the joy that was set before Him endured the cross, despising the shame, and is set down at the right hand of the throne of God* (Hebrews 12:2).

Once you have been equipped with understanding, you will be able to extinguish every fiery dart of the enemy and apprehend your joy, which is always set before you. It's always set before you to help you remain focused. So, think about it. What is your joy? What prize are you reaching for?

You first have to understand how the enemy is going to come at you. The why will come later as you seek God for your answer. You must understand how he's coming so that you can get on the offensive long before he gets there. And since he's good at his job, you'll have to be more determined to hold on to what you have received than he is to take it away from you.

Now that the fight is on, so to speak, you'll begin to feel some heat. You'll experience pressure like never before. You have to know in whom you believe once the heat is turned up and the darts begin to fly. You'll have to plant your feet firmly on the ground and refuse to be moved. You may bob and weave like an experienced boxer in the bout of your life, and you must refuse to be moved. When the fire is turned up as hot as it gets, you must refuse to be moved. When you begin to say, "My God, why have you forsaken me?" you must refuse to be moved. When there is nowhere to turn and it seems you're going down for the count, you must refuse to be moved.

Seeing as how I have no more sense than to believe God that lives will be changed forever and destinies will be apprehended, I would be remiss in my responsibility if I did not equip you with the understanding to put an end to all demonic harassment in your life.

The Word of God says, "Wisdom is the principal thing; therefore get wisdom: and with all thy getting get understanding" (Prov. 4:7).

If understanding is important to us, then it is also important to our enemies. Would you like to know what demons understand? They understand that the right information placed into the hands of the right believers will invoke the power of God in the lives of the believers. That means it's time for some combat training. One way to train for combat is to study those who have gone before you and apprehended their victory.

It's now time to kick this thing into high gear by studying the victory of Shadrach, Meshach, and Abednego. Through sheer obedience, they thwarted the enemy's plot to destroy them by using faith principles that you are about to learn and apply to your life.

They were victorious over the enemy and had they not handled the situation properly it would have taken them out. However, these situations were strategically set to take them to the next level in God. Had they given in at any point, they would have never made it through the ultimate test of their faith, the furnace, which positioned them for promotion.

From beginning to end, it looked as though their enemy was in control, but God never plays catch-up to satan's attempts to throw His people off track. God was in control from the very beginning. You should always remember that God is orchestrating everything that is going on in your life.

We give too much credit to the devil; satan is not in charge. God has orchestrated everything, including the final outcome, so that He gets the glory. Unlike Shadrach, Meshach, and Abednego, we never see the final outcome because we start moaning, crying, complaining, and pulling back before God can get the glory. One of the most important things for you to get embedded down in your innermost being is that if God hasn't gotten the glory, you're not finished with the test.

We all know the story of Shadrach, Meshach, and Abednego and how they honored God with a lifestyle of righteousness and ended up being thrown into a furnace. Many of you may not be able to identify with a physical furnace that has been turned up seven times hotter than normal, but I'm sure, that on occasion, you have felt the heat of your situation being turned up against you. I'm sure you knew that if God didn't show up, you would be destroyed. Let's take a closer look at our three courageous young men so we can come through the fire and watch it burn off the bondage and yokes of captivity and receive promotion from God.

> *In the third year of the reign of Jehoiakim king of Judah came Nebuchadnezzar king of Babylon unto Jerusalem, and besieged it. And the Lord gave Jehoiakim king of Judah into his hand….And the king spake unto Ashpenaz the master of his eunuchs, that he should bring certain of the children of Israel, and of the king's seed, and of the princes; children in whom was no blemish, but well favoured, and skilful in all wisdom, and cunning in knowledge, and understanding science, and such as had ability in them to stand in the king's palace, and whom they might teach the learning and the tongue of the Chaldeans* (Daniel 1:1-2,3-4).

Our story begins with Judah being taken captive by Babylon. But remember, I said that God is orchestrating everything in your life. "And the Lord gave Jehoiakim king of Judah into his hand" (Dan. 1:2). It's right there in the Word of God. God gave Judah and its inhabitants into the hands of the enemy; God allowed this to happen. Before you get indignant, remember God is going to get the glory, so just be patient. I know you can look back on your own life and see where you were going through something, and before everything was said and done, before you got to the point of destruction, God turned that thing around, and you've been singing His praises ever since. Then, after it was all over, you realized it was a Holy Ghost setup. Well, God set this up, He gave Judah over to

the hands of their enemy, and because of it, the saints have been singing His praises ever since.

> And the [Babylonian] king told Ashpenaz, the master of his eunuchs, to bring in some of the children of Israel, both of the royal family and of the nobility—youths without blemish, well-favored in appearance and skillful in all wisdom, discernment, and understanding, apt in learning knowledge, competent to stand and serve in the king's palace—and to teach them the literature and language of the Chaldeans (Daniel 1:3-4 AMP).

The Babylonians had waged war against Jehoiakim, king of Judah, defeating them and taking all of the inhabitants captive. This included the royal family and all of the nobility of the land. Then Nebuchadnezzar gave specific instructions to Ashpenaz, the master of his eunuchs, concerning the young men of the royal family and the nobility of the land of Judah. King Nebuchadnezzar wanted Ashpenaz to bring him the cream of the crop. He wanted young men who were the cream of the crop in integrity, intelligence, dignity, class, education, and in facial appearance. These boys were to be Judah's future leaders, and the enemy wanted them in his camp.

Past history shows that when someone is taken into captivity, there are still loyalties toward the life that they had before and resentments toward the lifestyle that is now being forced upon them. We know that our three young men were used to living the high life in the king's palace, so you might think it would be an easy transition for them going from one palace to another.

However, there was one thing that Nebuchadnezzar had not counted on. From birth, Shadrach, Meshach, and Abednego had been taught the ways and customs of their forefathers. They knew who God was, and they knew that they were the chosen people of God. They were well versed in their culture and in their history as a people, and they could recite every time God had brought them

through hardship; this was something that was embedded deep within their soul.

Because our three champions had been hand picked to serve the king, the king's men would have to take steps that would ensure that the young men would forget their past. They began by changing their names. We all understand that the people of that day were very particular about naming their children, because their names spoke of their destiny. All of their names spoke of something that the inhabitants of Babylon did not believe in: God.

The original names given to them at birth were Hananiah, Mishael, and Azariah. *Hananiah* means "God is gracious." Every time Hananiah's name was spoken, God's grace was being proclaimed into the atmosphere, a constant reminder of God's grace not just to Hananiah but to all those who called his name. But his name was changed to *Shadrach*, which means "at the command of Aku," a nonexistent Persian god.

Mishael's name means "who is like God?" So, every time someone called his name, they were asking who is like God, which in and of itself is a praise. It also allowed God to show up and demonstrate that there was no one like Him. Mishael gets his name changed to Meshach, which is believed to be the name of another nonexistent god.

Azariah means "God aids and takes care of me." How would you like it if every time your name was spoken into the atmosphere, it reminded you and everyone around you of the fact that God aids and takes care of you? His name is changed to Abednego, which means "a servant of [a Babylonian god]."

They were no longer reminded of the attributes of God when their names were spoken. No longer was Hananiah constantly reminded of God's grace over his life. No longer was Mishael reminded that there was no one like God. No longer was Azariah reminded that it was God who aided and took care of him. Not only were they not reminded, but it was not being spoken into the atmosphere.

As they walked out their everyday lives and their names were being proclaimed, the manifestation of that name was what was coming forth in the earthly realm. You parents had better be careful when naming your children. You should know what you're naming them. It shouldn't be something that you heard that sounds good or even something that you've made up. But it should be something that is going to speak of God's purpose and destiny into their lives. A name should be something that points you toward your destiny. You should also teach the child what the name means and make them understand that every time it is proclaimed in the atmosphere, they are that much closer to their destiny.

While we are on the subject of names and destinies, allow me to shine some light in another area that has remained dark until now. This is specifically to women who have been divorced. If you have gone through a divorce and you *do not* have children or your children are older, you should strongly consider taking back your own name, your maiden name. By still carrying your married name, you still carry everything that is in that genealogy, everything that goes along with that name, including generational curses. Some of you are afraid to go back to your own name because you're afraid of being your own person. It would be better for you to take what's in your own family line than that of someone else, someone with whom you are no longer connected. Your destiny is in your name; the very thing that God is going to manifest in your life is in your name.

A good name is better than precious ointment (Ecclesiastes 7:1).

You may not like your maiden name or the family you've come through; you may only be able to see the bad. But God knew what He was doing when He brought you through that family line. If you can't see how that is a blessing, then it's time for you to get alone with God and allow Him to show you all the good that's there and begin to appropriate the goodness into your life.

Now, from all the captives of Judah, Nebuchadnezzar instructed his men to take the cream of the crop and immediately change

their names. This was in the hope they would forget their destiny, the promises and prophecies that had been spoken over their lives, that they would forget their culture and from where they had come from. If they had forgotten, they would have forgotten every prophetic Word that had ever been spoken over them and their people. They would have forgotten that there was One coming who was greater than they were and greater than those who held them captive. Once you know who Jesus is, and it's deep down within you, no one can take that from you, because what you believe draws you, but what you know keeps you. So you may believe that something is good and possibly get sidetracked for a moment. Once the truth that you know starts to come up and begins to reveal the lie that the enemy is trying to get you to buy into, you'll leave that foolishness behind and continue your walk with God.

So, they were trying to make them forget their culture; the next thing they came after was their food.

> *And the king appointed them a daily provision of the king's meat, and of the wine which he drank: so nourishing them three years, that at the end thereof they might stand before the king….But Daniel purposed in his heart that he would not defile himself with the portion of the king's meat, nor with the wine which he drank: therefore he requested of the prince of the eunuchs that he might not defile himself. Now God had brought Daniel into favour and tender love with the prince of the eunuchs. And the prince of the eunuchs said unto Daniel, "I fear my lord the king, who hath appointed your meat and your drink: for why should he see your faces worse liking than the children which are of your sort? Then shall ye make me endanger my head to the king." Then said Daniel to Melzar, whom the prince of the eunuchs had set over Daniel, Hananiah, Mishael, and Azariah, "Prove thy servants, I beseech thee, ten days; and let them give us pulse to eat, and water to drink. Then let our countenances be looked upon before thee, and the countenance of the children that eat of the portion of*

the king's meat: and as thou seest, deal with thy servants." So he consented to them in this matter, and proved them ten days. And at the end of ten days their countenances appeared fairer and fatter in flesh than all the children which did eat the portion of the king's meat. Thus Melzar took away the portion of their meat, and the wine that they should drink; and gave them pulse (Daniel 1:5,8-16).

In offering them the king's food, they were trying to get the boys to relax and become common with their surroundings. When you become common with your surroundings, you lose your objectivity, and at some point you'll begin to compromise what you believe. This leads you to not being able to take a stand for what you once knew to be true. What the boys were saying was, "Nebuchadnezzar, we're in your land, but we are not common. We understand that we have a destiny, so we can't partake of all that is common to you and your kind because we have more in our lives than even you can see."

In my own life, God brought me to this understanding long ago. I can't associate with everybody, and I can't do what everybody does. I can be in some places, but I can only go so far when I'm there, because I'd be known as common. When you allow yourself to become known as common, you lose your effectiveness, because then you're just one of the crowd. So you can't associate with everyone, you can't do everything, you can't go everywhere, you can't touch and handle everything, and you can't eat everything. You have to be careful where you walk; careful people understand that their footsteps are ordered by the Lord. So just accept the fact that there are some places you shouldn't go.

I'm not just talking about nightclubs, either. If something is not fruitful in your life, then it doesn't need to be included as a part of your life. Any person or group of people that are not bearing fruit in your life should be cut off at the root. No matter what the relationship, it needs to bear some fruit in your life, or you shouldn't allow yourself to become common with it.

Another very important point that Shadrach, Meshach, and Abednego were declaring through their actions was that they feared God more than man. What people see is not as important as what God knows. It is more important that God knows that there is something He's deposited in you and that He's working through you, and at the appointed time He can pull it out of you. You must become less people conscious and get to the point that you don't care what they think of you. People are fickle, and what they think is always subject to change.

Now that Shadrach, Meshach, and Abednego had gotten it straight that they were not going to forget who they were put on the earth to be, they were not going to forget their culture or their God, they were not going to become common with the Babylonians, and they were going to live upright before their God, they were put to the ultimate test.

You should be aware that once you decide that you are going to live a certain way and nothing on this earth can deter you from that, someone or something has been assigned to challenge your way of life.

> *Nebuchadnezzar the king made an image of gold, whose height was threescore cubits, and the breadth thereof six cubits: he set it up in the plain of Dura, in the province of Babylon. Then Nebuchadnezzar the king sent to gather together the princes, the governors, and the captains, the judges, the treasurers, the counsellors, the sheriffs, and all the rulers of the provinces, to come to the dedication of the image which Nebuchadnezzar the king had set up.... Then an herald cried aloud, "To you it is commanded, O people, nations, and languages, that at what time ye hear the sound of the cornet, flute, harp, sackbut, psaltery, dulcimer, and all kinds of musick, ye fall down and worship the golden image that Nebuchadnezzar the king hath set up: and whoso falleth not down and worshippeth shall the same hour be cast into the midst of a burning fiery furnace"* (Daniel 3:1-2,4-6).

Here we have the king throwing a nationwide party to unveil this statue made of solid gold, standing 90 feet high and 9 feet wide. He invited every bigshot on his payroll to witness the love his people had for him by their obedience to his command. The music began to play, and the people went down on their knees. It was wonderful, and as far as the king knew, all was right with the world. That is, until he got the message that rained on his parade:

> *Wherefore at that time certain Chaldeans came near, and accused the Jews. They spake and said to the king Nebuchadnezzar, "O king, live for ever. Thou, O king, hast made a decree, that every man that shall hear the sound of the cornet, flute, harp, sackbut, psaltery, and dulcimer, and all kinds of musick, shall fall down and worship the golden image: And whoso falleth not down and worshippeth, that he should be cast into the midst of a burning fiery furnace. There are certain Jews whom thou hast set over the affairs of the province of Babylon, Shadrach, Meshach, and Abednego; these men, O king, have not regarded thee: they serve not thy gods, nor worship the golden image which thou hast set up"* (Daniel 3:8-12).

Isn't that just like the devil showing up to stir up trouble? Don't forget what I've already said: God is behind the scenes orchestrating your life. He never plays catch-up to anything satan is trying to do. God created satan, and he can't surprise God. But right here, the king was surprised. The king took Shadrach, Meshach, and Abednego in because they were the best of the best. He gave them the best that Babylon had to offer. And he hadn't a clue that they even remembered the God of their childhood, let alone that they still served him.

> *Then Nebuchadnezzar in his rage and fury commanded to bring Shadrach, Meshach, and Abednego. Then they brought these men before the king. Nebuchadnezzar spake and said unto them, "Is it true, O Shadrach, Meshach, and Abednego, do not ye serve my gods, nor worship the golden image which I have set up? Now if ye be ready that at what time ye hear the sound of the cornet, flute, harp, sackbut, psaltery, and dulcimer, and all kinds*

of musick, ye fall down and worship the image which I have made; well: but if ye worship not, ye shall be cast the same hour into the midst of a burning fiery furnace; and who is that God that shall deliver you out of my hands?" (Daniel 3:13-15)

Now, we can all understand the king being angry, but the Scripture says, "In his rage and fury." You have to understand what was happening there. The king was giving the world's biggest rock concert for the sole purpose of his "princes, governors, captains, judges, treasures, counsellors, sheriffs, and all the rulers of the provinces" to see just what a grand ruler he was. And here were three Hebrew boys that he had taken captive, brought into the palace, fed, clothed, and educated better than some of his own people, and "set [them] over the affairs of the province of Babylon," and they were not only refusing to bow to the image, but they were not hiding. They were openly defying the king. This had to be a bit embarrassing for the king. You know he was thinking that next year, when tax season rolled around, all of the high officials may not be so willing to give to a king who can't control those closest to him.

So, to save face, the king gave the boys another chance to bow; after all, maybe they just hadn't heard the instructions clearly. So he was going to give them another chance to do what he said they should do, even though what he said to do opposed everything they knew was right in God's sight. So he proclaimed that if they hear the music and fall down and worship the idol, then fine, but if not—and I really need you to catch this because this is what it's really all about—Nebuchadnezzar said, "But if ye worship not, ye shall be cast the same hour into the midst of a burning fiery furnace; and who is that God that shall deliver you out of my hands?" That's it, right there; Nebuchadnezzar was asking, "Who is this God?" In other words, satan was there, putting pressure on Nebuchadnezzar to try and break these boys the same way he puts pressure on those around you to get you to do what you know isn't right. Putting pressure on you like never before to bow down and worship someone else's evil

and misguided way of thinking and being, trying to make you question God and his ability to deliver you out of any situation.

Nebuchadnezzar asks them, "Who is this God?" In other words, "What God do you think is big enough to get you out of this situation?" I know you can identify with what's going on here. Someone may be asking you right now, Who is this God that can get you out of the fix with your mortgage company? Or what God can get you out of this dilemma with the loan at the bank that you're behind on? Or what God can fix the mess you've made of your marriage? Or what God can get your child off drugs, out of jail, or off the streets? What God is going to pay for your college tuition this semester?

Oh, wait, that's *your* life. Let's get back to Nebuchadnezzar. He's asking, "Who is this God who will deliver you out of my hands?" Remember, I told you that God was behind the scenes orchestrating everything that had to do with them, even allowing them to be taken captive.

God knew what was on the inside of them because He had placed it there. He also knew, when the time was right, what would come up out of them. And He knows what's on the inside of you because He placed it there. So, why don't you trust Him enough to know what's going on in your life and know how to bring you through it? It may not be the way you want to get delivered, but remember, it's going to position you for a better future and destiny. Begin looking to God and not what the people are saying around you. It's not important what people see, but it's very important what God knows. Shadrach, Meshach, and Abednego were in slavery, but they had no fear of man because they knew that the One inside of them was greater.

Shadrach, Meshach, and Abednego, answered and said to the king, "O Nebuchadnezzar, we are not careful to answer thee in this matter. If it be so, our God whom we serve is able to deliver us from the burning fiery furnace, and He will deliver us out of thine hand, O king. But if not, be it known unto

thee, O king, that we will not serve thy gods, nor worship the golden image which thou hast set up" (Daniel 3:16-18).

Shadrach, Meshach, and Abednego stood their ground when they answered the king and began with "We are not careful to answer thee in this matter." They wanted it understood that this was something they didn't have to pray about or discuss with one another or ask for opinions from anyone present. Their minds were made up and their hearts were fixed and they weren't budging from where they stood. Next they said, "If it be so." Have you ever asked yourself, "If what be so?" They were stating that if it be so that the king chose to follow through with his threat and throw them into the furnace, God would deliver them out of the furnace and out of the king's hand. Then they added, "But if not." But is a conjunction that ties this all together. They were saying: "But if you chose not to throw us into the furnace, we still won't serve your gods or worship the golden image that you have set up."

Our three young men have just decreed what's about to take place whether they go in the furnace or not. "Thou shalt also decree a thing, and it shall be established unto thee: and the light shall shine upon thy ways" (Job 22:28). When you decree a thing, God will establish it. A decree is an order that is enforced by the authority of God. So the boys decreed that "God…is able to deliver us from the burning fiery furnace, and He will deliver us out of thine hand."

There is another young man who decreed the outcome of his situation and saw God's saving grace work for him. David, the young shepherd boy, decreed what would happen when he faced Goliath. David declared what he was going to do and followed through with every single step from beginning to end.

This day will the Lord deliver thee into mine hand; and I will smite thee, and take thine head from thee; and I will give the carcases of the host of the Philistines this day unto the fowls of the air, and to the wild beasts of the earth; that all the earth may know that there is a God in Israel (1 Samuel 17:46).

David did exactly what he said he was going to do. He said he was going to smite him, and he did. He said he was going to cut his head off, and he did. He said he was going to feed his body to the birds and wild beasts, and he did. When the Philistines saw their champion fall, they fled, leaving Goliath's body there for the birds and wild beast to feast on, just as David said. You've got to be the same way. You must be clear and decisive and decree what you will and will not tolerate from the enemy and follow through with your decision.

Our three young Hebrew champions were adamant. They stated, "Our God whom we serve is able to deliver us from the burning fiery furnace, and He will deliver us out of thine hand."

> *Then was Nebuchadnezzar full of fury, and the form of his visage was changed against Shadrach, Meshach, and Abednego: therefore he spake, and commanded that they should heat the furnace one seven times more than it was wont to be heated. And he commanded the most mighty men that were in his army to bind Shadrach, Meshach, and Abednego, and to cast them into the burning fiery furnace. Then these men were bound in their coats, their hosen, and their hats, and their other garments, and were cast into the midst of the burning fiery furnace. Therefore because the king's commandment was urgent, and the furnace exceeding hot, the flames of the fire slew those men that took up Shadrach, Meshach, and Abednego. And these three men, Shadrach, Meshach, and Abednego, fell down bound into the midst of the burning fiery furnace* (Daniel 3:19-23).

Notice what it says: "Then was Nebuchadnezzar full of fury, and the form of his visage was changed." In the Amplified it says: "Then Nebuchadnezzar was full of fury and his facial expression was changed [to antagonism] against Shadrach, Meshach, and Abednego." It wasn't until this very point that Nebuchadnezzar was actually angry enough to do something. It wasn't until this very point that Shadrach, Meshach, and Abednego stood before all of the king's high-ranking officials and openly defied his commands. Now they are face-to-face with someone who has deceived himself

into believing that he holds their destiny in the palm of his hand, and he is just as determined not to be denied as they are determined not to bow. What would you do in a situation like this?

It never fails. As soon as you refuse to go along with someone's agenda, they'll become furious and turn against you. It's a control thing. They get mad and make a few idle threats, and you back down and give in, and everything is normal again. But the very instant you believe that you are meant for bigger and better things, that's when they turn up the heat and the darts begin to fly. The heat is the pressure you feel to conform to their way of doing things. Sometimes the heat comes from within you when you aren't fully persuaded, when there is some part of you that wants to be accepted so badly that you are willing to compromise. The darts are the words and attitudes that are sent your way to make you conform. This is where you'll run into one of two types of people—both rooted in control. The first is the Nebuchadnezzar type. They don't hide anything. They let you know up front who you're dealing with; they are truly arrogant control freaks, and they don't care who knows it.

Then you have those who use manipulation to control you to get what they want. They're constantly working to undermine what you believe so they can suck you into their web of deceit so that they can get you to do their bidding. The first time that you take a stand by refusing to do things their way, they'll come against you. They don't come out in the open and let you know that they are furious with you; they'll just begin picking at you, secretly undermining your efforts to live upright before God. You try to engage them in simple conversation, and they give you an attitude. You're left wondering, "I thought they liked me, so why are they acting this way?" These are always those who you've allowed to get close to you: family or friends and sometimes coworkers. And because they are close to you, that just adds to the pain of the situation. When you're rooted and grounded in the Word of God, just like our three champions, the heat of your situation and the fiery darts that come

at you won't affect you the same way that they would if you needed the acceptance of those around you.

One way that you can tell where you are is whether or not you take this as being your problem. Instead of stepping back and re-evaluating the relationship in the light of God's Word with the help of the Holy Spirit, you take on their problem. Once you begin to question their treatment of you with the intent of fixing the problem, you've just taken on their problem. The truth is, you can't fix it, because it doesn't belong to you. You've got to learn to let other people's problems be their problems. You must understand that you can't fix it; you go to God to get right, and they must learn to do the same thing. What good is it for you to grow from your experience with God if you're always trying to fix things for other people and they never get the chance to grow?

Let's say that God does reveal the truth behind the situation to you, but you don't stay there long enough to get instructions about how to handle the matter. You just run off on your own and try to fix everything. You can't fix it because you can't fix them.

I've learned when someone has a problem with me, it is their problem. If they are mature enough to bring it to me, then I'll deal with it. But if you've got a problem and you're not mature enough to bring it to me, then it's your problem, and it doesn't affect me. I refuse to let it enter my space. I refuse to let it regulate the way I act. People will tell me, "You knew I was upset with you." But until they are willing to get it straight, they will be the only one upset, because I choose not to be upset with them. I choose to keep my space and my atmosphere clear because I've got a destiny to achieve. I refuse to become common with their issues. People are fickle. They'll be upset today and all right tomorrow. So, it's your problem, and I refuse to allow it to become my problem. By doing so, I can keep my heart fixed on what God has for me. Just like Shadrach, Meshach, and Abednego.

No one is trying to fix Nebuchadnezzar's problems. All the people around him are afraid they'll be thrown into the furnace, so they're falling in line with his request. Shadrach, Meshach, and Abednego have their marching orders from their commander-in-chief: God. "Therefore he spake, and commanded that they should heat the furnace one seven times more than it was wont to be heated." Remember the one common thread running through this teaching: God is orchestrating everything in their life and yours. Nebuchadnezzar spoke the words into the atmosphere to turn the furnace up seven times. However, it was God who gave the command. God used the king to speak His will. Have you ever wondered why the furnace was turned up seven times? The boys did all they knew to do, and now it was time for God to get involved. God couldn't get involved until this test was complete in their lives. Seven is the number of divine completion. The boys had proven themselves, and God stepped in and put an end to what the enemy had planned for them.

Before God put an end to what was going on, the very men who escorted Shadrach, Meshach, and Abednego to the fire were destroyed by the fire. "Therefore because the king's commandment was urgent, and the furnace exceeding hot, the flame of the fire slew those men that took up Shadrach, Meshach, and Abednego." Now catch this: God allows your escorts to come along side, those who have been throwing the fiery darts and making sure the heat stays turned up. God allows them to escort you to the very place that they think will destroy you, but when you get there that fire is going to destroy them. God promised that He would "[prepare] a table before me in the presence of mine enemies" (Ps. 23:5). God will allow your escorts to come along, but if they can't get into agreement with what He's going to do in your life, now that He has prepared the table in front of them, He's going to wipe them out.

However, they can't be wiped out until the fire coming against you has been turned up seven times, and this is the point where, as Christians, we lose it. Did you notice that when the escorts came to bind them and throw them into the fire, they never got afraid? Nor

did they murmur or complain. When they got to the fire and the fire destroyed the escorts, they never drew back. They had decreed that if the king chose to throw them in, God was going to deliver them. They had made their decree known and left the rest up to God.

When we feel a little heat, we get afraid and back away from what looks like our destruction. Some of us even begin to rationalize everything in our minds by saying, "Well, you know it must not have been God. God would never do this to me." Then we try to pull back to a place where we're comfortable, where nothing is moving in our lives. This challenge, the darts and fire, is allowed to get you off one level to the next. Everybody can't take the fire. Not everybody is willing to prepare and discipline themselves to face the demons that have been holding them back. Not everyone is able to live outside of their comfort zone.

So, the fire kills the escorts, and our three champions of faith are thrown into the furnace. Nebuchadnezzar thought he was putting Shadrach, Meshach, and Abednego in the fire, but Hananiah (God is gracious) went into the fire, and Misheal (Who is like God) went into the fire, and Azariah (God aids and takes care of me) went into the fire. Their purpose walked into the fire, and their destiny walked into the fire, and since they didn't move in fear when the furnace was turned up seven times hotter and wiped out the escorts, their Redeemer walked into the fire. The answer to their dilemma walked in there with them. And the same fire that killed the escorts loosed the chains that tried to keep them bound.

Then Nebuchadnezzar the king was astonished, and rose up in haste, and spake, and said unto his counsellors, "Did not we cast three men bound into the midst of the fire?" They answered and said unto the king, "True, O king." He answered and said, "Lo, I see four men loose, walking in the midst of the fire, and they have no hurt; and the form of the fourth is like the Son of God." Then Nebuchadnezzar came near to the mouth of the burning fiery furnace, and spake, and said, "Shadrach, Meshach, and Abednego, ye servants of the most high God, come forth, and

come hither." Then Shadrach, Meshach, and Abednego, came forth of the midst of the fire (Daniel 3:24-26).

This is one of the most interesting points of the entire teaching. The very one who questioned their God, without any teaching or prompting from anyone, immediately recognized their God when He showed up. And the same thing is going to happen in your situation. When God shows up to deliver you, everyone around you who questioned God's ability will recognize God and the fact that they can't touch you.

> *And the princes, governors, and captains, and the king's counsellors, being gathered together, saw these men, upon whose bodies the fire had no power, nor was an hair of their head singed, neither were their coats changed, nor the smell of fire had passed on them. Then Nebuchadnezzar spake, and said, "Blessed be the God of Shadrach, Meshach, and Abednego, who hath sent His angel, and delivered His servants that trusted in Him, and have changed the king's word, and yielded their bodies, that they might not serve nor worship any god, except their own God. Therefore I make a decree, that every people, nation, and language, which speak any thing amiss against the God of Shadrach, Meshach, and Abednego, shall be cut in pieces, and their houses shall be made a dunghill: because there is no other God that can deliver after this sort." Then the king promoted Shadrach, Meshach, and Abednego, in the province of Babylon* (Daniel 3:27-30).

Nebuchadnezzar said, "Therefore I make a decree, that every people, nation, and language, which speak anything amiss against the God of Shadrach, Meshach, and Abednego, shall be cut into pieces, and their houses shall be made a dunghill; because no other God can deliver after this sort." You know you're bad when you have the heathen recognizing you and singing your praise. That's the God we serve, as long as we do what we know to do, He'll show up to deliver us in such a way that everyone knows it's Him.

But our story doesn't end there. It would have been enough for any one of us to be rescued out of the fire and given our lives back, but God wasn't finished. The Scripture says, "Then the king promoted Shadrach, Meshach, and Abednego, in the providence of Babylon." Even though the king knew nothing about this, nor did our champions, God had planned it all along. It's also what He has planned for your life.

You need to understand that if you're going to the next level, and if you believe that God is going to make something out of you, you've got to go through the fire, because your answer is in the fire. The fire has to be turned up seven times hotter than usual so that the work can be complete. You may be thinking that you've been in the fire for a while now. Don't fret; you may just be at level 2. There's no sense in fainting now, because you've got five more levels to go. You can't pull back to where things were comfortable and get some relief. You just need to begin to praise God. When the fire gets hotter, I'll praise Him all the more. When the fire gets hotter, I'll quote more Scriptures. When the fire gets hotter, I'll rejoice and dance unto my God. I am determined to walk in my destiny, and there isn't a fire made that will deter me from that. It's your lifestyle of dedication and praise that got you thrown in the fire in the first place, so don't back down now. Your answer is in there, and you'll receive it as long as you refuse to compromise.

CONTACT THE AUTHOR

DR. TERRI SMITH-LITTLE

D.I.V.A. International, Inc.
9203 S Hwy. 6 #206,
Houston, TX 77083

Phone: 281-498-5683
Fax: 281-545-1053

E-mail: diva@diva1.org
Website: www.diva1.org

Additional copies of this book and other book
titles from DESTINY IMAGE EUROPE
are available at your local bookstore.

We are adding new titles every month!

To view our complete catalog online, visit us at:
www.eurodestinyimage.com

Send a request for a catalog to:

**Via Acquacorrente, 6
65123 - Pescara - ITALY
Tel. +39 085 4716623 - Fax +39 085 9431270**

"Changing the world, one book at a time."

Are you an author?

Do you have a "today" God-given message?

CONTACT US

We will be happy to review your
manuscript for a possible publishing:

publisher@eurodestinyimage.com